D0270243

Collecting Antique Silver

Concorde Books

Collecting
Antique Silver

Judith Banister

Ward Lock Limited
London

© Ward Lock Limited 1972

Casebound ISBN 0 7063 1332 1
Paperbound ISBN 0 7063 1813 7

First published in Great Britain 1972
by Ward Lock Limited, 116 Baker Street,
London, W1M 2BB.

All Rights Reserved. No part of this
publication may be reproduced, stored
in a retrieval system, or transmitted, in
any form or by any means, electronic,
mechanical, photocopying, recording, or
otherwise, without the prior permission
of the Copyright owner(s).

Designed by Michael R. Carter

Text set in Baskerville (169)

Printed Offset Litho and bound by
Cox and Wyman Ltd.,
London, Fakenham and Reading

Contents

Introduction

The 160 years from the Restoration to the Regency might well be called the heyday of English domestic silver. Fine quality silver was, of course, produced in medieval and Tudor times, but the upheavals of the Civil War in the seventeenth century meant that tremendous quantities were lost, and little remains available to the collector dating before the return of Charles II in 1660. Equally, there has been good silver made in the years since 1830, and much silver of the reign of William IV and Queen Victoria, not to mention the silver of our own times, deserves attention.

From the collector's viewpoint, however, the late seventeenth century and the whole of the eighteenth century, overlapping into the first thirty years of the nineteenth, remains the chief attraction. The layman often, of course, gets a false impression, especially from auction reports in the Press, when record prices are usually reported, that all early English silver is prohibitively expensive. In fact, English silver, even of the topmost quality, is much under-priced by the standards of any other works of art, and there are innumerable small and worthwhile objects to attract the collector and which change hands for quite small sums. For the collector of modest means, who may aspire to but never acquire, a Lamerie coffee-pot or a Hester Bateman waiter, there are dozens of minor pieces by worthy silversmiths, pieces that are frequently both useful and ornamental as well.

More and more, collectors have come to realise that there are dozens of other individual silversmiths worthy of their attention than the 'famous names'. Many were specialist makers – Charles Adam, Thomas Bamford and Samuel Wood were primarily caster makers, for instance, the Hennells excelled at salts and pierced work, the Cafes at candlestick-making, while others were spoon-makers, salver-makers, basket-makers and so on. In the smaller world of the eighteenth century, styles were assimilated rapidly and well, so that even small objects were soon made in the latest popular manner by lesser craftsmen. This book sets out to describe those changing styles as they affected not only the great designers such as Lamerie and Storr, but every working silversmith in Britain.

On Collecting Silver

One of the joys of silver is the variety of things that were made in this beautiful metal. Since the Restoration of King Charles II, almost everything used at table and a good many household effects as well, in addition to items for personal adornment, have been made in silver. At one end of the scale there is the now unobtainable and only rarely surviving silver furniture. Then there are massive wine coolers and wine fountains, great chargers, ewers, basins for rose-water, flagons and table centres. These items – really museum pieces – are outside the scope of the ordinary collector, but should be viewed whenever the opportunity presents itself. At the other end of the scale – and very much within the scope of the collector – there are little things made in silver for those who could not afford gold about their person – snuff- and tobacco-boxes, for instance, patch-boxes and vinaigrettes.

In addition to domestic and decorative items silver was used in the making of a wide variety of other objects and a special knowledge can – and does – often lead to fascinating collections. A doctor, for example, may find himself intrigued by the wide variety of surgical and other medical instruments which probably go unrecognised as oddities by the general collector. Those interested in gaming may find great pleasure in collecting the silver counters and other pieces connected with such pastimes. For the sportsman there are many interesting trophies, a great many of them far less mundane than the ubiquitous silver cups and medals of today. In the seventeenth century, for instance, porringers, thistle cups and swords all featured as race prizes, while the next hundred years saw punch bowls, tumbler cups, and even coffee-pots on the racecourse. Even the nineteenth-century sportsman was not always restricted to cups, and silver churchwarden pipes, bugles, a silver fishing-reel and silver dog-collars made appropriate items – and very collectable, too!

There is no end to the variety of subjects that the silver collector can use to interesting – and sometimes profitable – advantage. The man who has travelled or lived in the East may like to collect pieces with an eastern flavour – perhaps the early so-called 'Buddha

knop' spoons, or silver decorated in the Chinese taste, or that made abroad for British colonials. The housewife collector can find enjoyment in kitchen pieces, from great preserving pans to small saucepans for warming brandy or sauce – or, more likely, cream which was warmed to take in tea in the early part of the eighteenth century. There are, too, rarities such as cream skimmers and pie dishes in silver, as well as small pieces such as apple-corers, nutmeg-graters, wine-funnels and ladles.

Pieces engraved with inscriptions make a fascinating study. Not all inscriptions are contemporary with the piece, nor are all by any means important, either historically or as works of art. Some are just charming tokens of affection or esteem; some record events or societies which must send the collector to pore over books and other records to build up the story that enhances the piece. Occasionally the collector of historical silver has his find enriched by documentary or other evidence.

Provincial silver attracts many different types of silver collector; the hallmarks enthusiast finds in it a splendid variety of marks. The collector concentrating on early pieces usually has a choice between London spoons and provincial pieces. For the student of unmarked or partly marked silver, there is plenty attributable to the provincial centres, while a man living in the country is often in a position to find locally made and marked pieces to help his collection along.

Keeping up with new discoveries about makers and marks is often a heavy but nevertheless essential and rewarding task, and one that adds much to the pleasure of old silver. The collector needs to have a good and reliable memory for marks and for forms and styles. Even if his particular interests do not extend to the whole field of English silver, he should at least have a working knowledge of pieces outside his own sphere, and, indeed, outside the world of silver altogether. There are many interesting parallels to be drawn with other arts and crafts, especially pottery and porcelain, furniture and architecture. More than one craftsman trained in silver has made his name outside his trade – Hogarth turned to painting and engraving; Nicholas Sprimont was the first manager of the Chelsea porcelain factory; and in reverse, masters of other crafts, such as Robert Adam, John Flaxman and C. H. Tatham had extensive influence on the work of silversmiths. Com-

parison with Continental and other silver work makes a useful study, especially in judging how much overseas influence and inter-change of design ideas obtained at any special period. Painting and literature likewise can furnish the collector with information that helps to bring silver into perspective with the history of English art.

Collecting scraps of information, photographs and illustrations of different pieces, great or small, museum and saleroom catalogues, magazine articles and dealers' advertisements in the weekly and monthly magazines can all help to build up the ordered history of silversmithing in England. With practice one should be able at a glance to distinguish the approximate date of a piece of silver. Knowing silver in this way is very helpful in dealing with unmarked silver. Indeed, to pick up a piece and attribute it to a place and date, possibly even a maker as well, is a useful and stimulating practice. This should always be done before looking for the hallmarks, and, if there is none there, then at least the piece has been assessed on its intrinsic qualities first of all. Dating a piece on its appearance is not so difficult as it may sound. The pace of change in silver design has always been slow, and changes, when they have come, have always been clearly perceptible and datable.

To handle silver often is, of course, a vital part of learning about it. The feel of silver is somehow almost as critical as its appearance. There is no point, unless to collect a rare mark, in buying flimsy or badly-designed silver. A broken piece that cannot be satisfactorily mended without additions (and therefore later hallmarking) is virtually valueless, whatever its marks. Silver is meant to be used, not kept in a glass case as though too delicate to be handled and enjoyed.

Many collectors, especially those starting a collection and of modest means, are hesitant about asking advice. In later years they often learn, to their surprise, that other silver collectors, among them the reputable silver dealers, are more than ready to talk about silver at almost any time of the day or night. A good dealer is a good friend. He will advise, he will seek out the sort of silver that suits the collector and, while no one would expect him to work for nothing, his prices are often very reasonable, and the time he spends looking out for pieces, his advice and knowledge are invaluable and worth more than his percentage of profit.

A Short History of English Silver

By far the greatest quantity of English silver was made in London, although there are long, strong and high-quality traditions of craftsmanship in other parts of the country. Exeter, Chester, Newcastle, York and many other towns were centres of silversmithing for many centuries. Now, of the provincial assay offices where silver has to be tested and marked, only Birmingham and Sheffield, both set up in 1773, are left outside London.

London, as the centre of government, commerce and culture, has always attracted wealth, and where there is wealth there are goldsmiths and silversmiths. During the seventeenth century wealthy goldsmiths often concerned themselves with usury and banking, and even during the eighteenth century not a few silversmiths advertised that they kept 'running cashes'. This was, in fact, quite a logical situation. Gold and silver were, in effect, so much bullion that happened to be on hand in a pleasant and useful form.

The patron of the silversmith still tended to look on his plate as a sort of bank-balance. After all, it was of the same sterling standard as the coinage, so conversion was simple enough. In the same way, if he grew bored with the design of his silver (often known as *white plate*) or his silver-gilt (carelessly dubbed *gold* or *gilt*), then he just had it melted down and re-made in the style of current fashion.

The Restoration of Charles II in 1660 is usually considered the beginning of the era of domestic English silver. The Church during the Middle Ages had been the patron of the arts, but the ravages of

Henry VIII's Reformation had taken a heavy toll of medieval treasures. Added to that there had been the heavy demands of wars over the centuries, the lavish gifts made to foreign potentates and, finally, the wholesale destruction of plate to support one side or the other during the Civil War (1642–8) – quite apart from wear and tear and the common habit of melting down plate to have it re-fashioned. For the collector, pre-Restoration silver, even small articles such as spoons, beakers, tumbler cups and wine tasters, is often beyond reach. This is not to suggest that silver of the medieval, Tudor and early Stuart periods should be ignored.

The Renaissance, which came late to England and did not make much impact on silver until the 1530s, was the source of all European design tradition for centuries to come. Its decoration, based on revived classicism, with flutes and acanthus leafage, swags of fruit, flowers and scrolls, satisfied the appetite of artists until almost the mid-eighteenth century when its themes became out of hand, and it needed Robert Adam and the neo-classicists to formalise its motifs by returning to the ancient originals once more.

The influences on the design styles of English silver, from Holbein the Younger at the court of Henry VIII to that of Van Vianen at Charles I's court, were always European. Foreign silversmiths working in London and elsewhere were no phenomenon. There was during and immediately after the Civil War a break in the history of the craft. For more than a decade before the return of Charles II the trade, in London at any rate, was virtually at a standstill.

The Restoration coincided with new developments in science and industry, art and architecture, trade and overseas enterprise. Those who had joined the Royal Family in exile returned and set about rebuilding their houses, farming the new estates assigned to loyal supporters, and replenishing their stores of plate. There were the large and prosperous middle classes, all quite prepared to emulate their wealthier neighbours. For the silversmith, the return of Charles II in May, 1660, was the beginning of a long era of work and prosperity. With trade at its lowest ebb there were problems, but the craft promptly celebrated the occasion by deciding to change the annual date-letter (struck on all plate) from the traditional May 19th, St. Dunstan's Day, to May 29th, the King's birthday.

With the Restoration came an upsurge of demand for bold and showy silver and silver-gilt. As usual, the impetus came from abroad, and the returning court brought new styles home with them. Both France and Holland wielded great influence on silver design. Louis XIV was still a young man, but his famous '*L'etat, c'est moi*' was a dictum already five years old. In Holland, there was the impact of the floral baroque. The swirled and lobed style of Van Vianen gave way to exuberant flowers and foliage, birds and animals – still bold, still with the emphasis on embossing and chasing, but reflecting the Dutch interest in natural history.

The two-handled cups, variously called porringers, caudle cups and posset pots, are probably the most typical of all Charles II silverwares. Posset and caudle were both spiced milk drinks, curdled with wine or ale and taken hot, so that handled cups were most necessary. The rather squat bulging bodies of these cups were usually embossed and chased with flowers, foliage and animals. A lion on one side and a unicorn on the other – sometimes varied by bears, hounds, deer, boars, goats and the like coursing round the sides amid the foliage – were popular motifs, the bold style of the embossing serving to conceal the rather thin metal. Silver remained in short supply, and demand was heavy – and did not wane. A typical feature of the bulbing-bodied porringers was the cast caryatid handles, which became progressively more spindly and more formalised, so that some appear as slender, double scrolls with leafy blobs for heads instead of curvaceous maidens.

Standing cups were made again, sometimes in styles that harked back to the originals that had been melted down. Occasionally, replicas of the great standing salts were made – mostly in the capstan shape on a circular or square base with a waisted spool support for the salt, and with scrolls which presumably held a napkin to keep the salt covered. But the days of the high table were virtually over, so that silver for show was more likely to be in the form of garniture for the mantelpiece or fireplace – vases and jars with no other purpose but to gleam and look splendid in firelight and candlelight. Between ten and fifteen inches high, they were enriched with floral and foliate embossing enclosing cherubs or masks and with richly festooned work applied round the necks.

Equally richly ornamented were the silver sconces for one or two candles, with shaped oval back-plates, and the impressive toilet services with perhaps a dozen or sixteen pieces, including mirror, jewel caskets, pin cushion, flasks, flagons and dishes – and even covered bowls elaborately chased with scrolls, leafage and *amorini* in high relief.

Not all Charles II silver was rich and gaudy. There had been a leavening in the French style of 'cut-hard' work introduced about 1650. Cut-card ornament, consisting of thin silhouettes of silver soldered round the bases of bowls and cups, and round finials and handle sockets, was an effective way of helping to strengthen thin-gauge metal. Some silver, notably tankards, wine cups and the heavy-based small tumbler cups, on the whole escaped the current passion for overall decoration, other than perhaps a band of acanthus leaf chasing or an engraved coat-of-arms in a plumed mantling.

In the Commonwealth period, the beer tankard had a spreading base, aptly called a skirt foot, and replaced the so-called 'Puritan' type with its base in one with the body and without a foot. By 1660, the rim foot and a slightly tapering cylindrical barrel established the type of tankard that was to be little changed for more than half a century. Unlike the handles on bowls and cups, tankard handles were broad scrolls, sometimes with hoof-like terminals, and with a cast, bifurcated or two-lobed thumbpiece. Tankards were almost always covered, the lid being a flat-domed cap with a small wavy or pointed peak at the front. Base and lip were usually simply moulded or reeded. Incidentally, the small holes found at the base of the scroll handles, sometimes shaped rather like the mouthpiece of a wind instrument, were simply blow-holes to allow the air to escape when the handle was soldered on.

Wine cups, soon to be ousted by glasses, were also of the styles most copied in glass. They had a trumpet-shaped bowl and simple baluster stem on a circular moulded foot. Following a really old-established tradition were the small beakers, made in various sizes from about two and a half to seven inches high. They had cylindrical bodies flaring to the rims, and might be plain or decorative as taste and money dictated. Another commonplace in silver were the delightful little tumbler cups which were probably used for

spirits or other strong liquors. Rarely more than a couple of inches high, they are heavy-based so that they return to upright even when tilted.

About 1670 several new styles made their appearance in England, though of these only acanthus leafage and fluted baroque (also of Dutch derivation) survived to the end of the century, given new impetus with the arrival in 1689 of Dutch William III on the throne of England.

The baroque was really a formalising of the Dutch naturalistic style. The emphasis was still on embossing and chasing, but they became more restrained. Alternating palm and acanthus leaf chasing was arranged around the bases of cups and tankards, or round the broad rims of dishes. Fluting, both straight and swirled, was similarly used on the lower parts of drinking vessels, and it was a style admirably suited to the column candlesticks of the period, which gradually became plainer until ousted by the cast baluster candlestick in the 1680s.

One unusual and rather rare style used for display plate was to make a tankard or cup quite plain, gild it and then sheathe it with a pierced and chased sleeve, letting the gilded plate beneath gleam through the pierced foliage and flowers, animals, birds and amorini.

Chinoiserie, or decoration in the Chinese taste, has been a recurrent style in the history of English silver. Its earliest manifestation, from about 1675 to 1690, appears to have been one of the few entirely English decorative inventions. Lightly sketched and rather inaccurate palm trees, spiky foliage and flowers provided a setting for warriors in short tunics or sages in flowing kimonos, for temples and pavilions, for exotic birds and butterflies. Cups, porringers, tankards, bowls, salvers, jars, vases and complete toilet sets were treated to this rather naïve ornament.

Tea, coffee and chocolate, all of which were introduced to England about the middle of the seventeenth century, quickly became popular. Fashionable beverages needed silverwares from which they could be served. The silversmiths' reaction was to adapt the tall flagon, making a tall, tapering, cylindrical pot with a spout and handle. It was a practical and acceptable form that soon established itself as the universal style for both coffee and chocolate, the only difference between the pots for the two drinks being the

16

provision of a small hinged lid within the cover of the chocolate-pot through which the stirrer rod could be inserted.

The earliest known teapot (dated 1670) is in fact identical with the typical coffee-pots. It seems to have been an exception, however, and most of the earliest surviving teapots resemble small Chinese winepots, perhaps derived from porcelain or stoneware originals.

The second half of the seventeenth century saw a large rise in the consumption of both sugar and spices, and the first casters in silver date from the reign of Charles II. Here again, the straight-sided cylinder provided the basic style, with a high-domed, pierced cover held in place by sturdy bayonet clamps. Like most of the straight-sided wares of the silversmith, casters called for little decoration, and ornament was chiefly restricted to piercing, a shallow band of fluting or acanthus chasing, cut-card work or engraving.

Perhaps it was the prosperous state of life in England that made the persecuted craftsmen of France turn to Britain when Louis XIV revoked the Edict of Nantes in 1685. For some years less and less toleration had been shown to the Protestants in France, and many Huguenots did not wait for the final blow in 1685 before they fled to friendlier countries. Many of the Huguenots were craftsmen, silversmiths among them.

In 1682, Pierre Harache, an exceptionally fine craftsman, managed to break down the trade's resistance and obtained his Freedom of the Goldsmiths' Company. His was as yet a rare case of success, but he and his fellow Frenchmen, most of them from the provinces, were soon exerting a tremendous influence on English silversmithing and laying the foundation for the supremacy of English silver during the coming century.

The Huguenot tradition was one of fine craftsmanship, sturdy-gauge silver and meticulous decorative detail. They brought with them, no doubt, the design books they used in their native towns of Metz, Rouen, Poitou and so on – design books that laid emphasis on the detailed ornament known in France as *Régence* – ordered arrangements of strapwork enclosing scrolls, shells, husks and foliage, of applied lion and human head masks, of delicate cut-card and other applied work. They also brought a new variety of forms, based chiefly on the baluster shape. They introduced the cast

baluster candlestick and ousted the fluted column type; they turned the straight-sided flagon into a graceful ewer with a broad high lip and flying scroll handle; they heightened the two-handled cup, making it well proportioned and elegant with a moulded rib round the body together with sturdy scroll- or harp-shaped handles, thus ridding the silversmiths' shelves for good and all of bulging-bodied cups and coarse and ungainly embossing. Formality, simple curves and detail design and decoration were the keynotes of Huguenot work.

From the time of the great influx of Huguenot craftsman two distinct styles emerged – one continuing the traditions of English baroque, the other of definitely French inspiration. At times, the two merged. Silver for coffee, for instance, largely remained in the English tradition, the straight-sided, cylindrical pot with a curved spout at right angles to the scroll handle being accepted as the general style by all the silversmiths. Established, too, was the baluster cast candlestick (though the earliest ones were in fact the work of Pierre Harache in the early 1680s); with moulded, octagonal bases with sunk centres and knopped stems with cylindrical sockets, they set the style for the next half-century.

The English silversmiths seem to have remained the chief makers of some wares – perhaps understandably, since the use of silver for beer and punch drinking was typically English. Tankards remained plain and capacious; punchbowls and wineglass coolers were relics of the baroque, with fluted and gadroon-bordered panels and scalloped rims chased with cherub masks, scrolls and acanthus foliage in the most honoured baroque tradition.

At that time the Government was beginning to take a critical interest in the craft. So great was the demand for silverwares that not a few silversmiths were apparently using the coinage of the realm to make plate. In March, 1697, the Act 'for encouraging the bringing in of wrought plate to be coined' reversed the process. In addition, all new wrought silver had to be of a higher standard of fineness than sterling, which had been in force since 1300. This higher standard silver, containing 3·3 per cent more silver, was known as the *Britannia Standard* because the plate had to be marked by the assay offices with a punch showing 'the figure of a woman commonly called Britannia'.

The period of Britannia silver lasted from March, 1697, until

June, 1720. Silver of this period was frequently quite plain, relying for its appeal on the beauty of line and the soft reflected mouldings. Britannia takes decoration very well and in skilled hands can be fashioned more satisfactorily than sterling. It was merely a coincidence that much silver of the period was plain. Indeed, even after 1720 when the higher standard was no longer obligatory, Paul De Lamerie, acclaimed justly as one of the greatest of all silversmiths, continued to use it for another twelve years, not even troubling to register a mark for sterling until 1732. Any implication in the wording of the Act of 1719, which restored the old sterling standard, that the new standard was too soft was probably due to the silversmiths' desire to be allowed to use the less costly sterling.

In the early years of the Britannia period, coinciding with the reign of Queen Anne, the Huguenot styles gradually gained an ascendancy over the native ones. Probably patrons found the French designs to their liking, and the English silversmiths had perforce to follow suit.

The baluster form soon dominated most silverwares. Casters, candlesticks, jugs and teapots showed gracious curves. Coffee-pots, though mostly straight-sided, conformed with curving swan-necked spouts and scroll handles. Even some mugs and tankards appeared with tucked-in base on a circular moulded foot. The teapot of the Queen Anne period had grown away from the wine-pot style into a squat pear shape, with a high-domed cover and curved spout. Following suit was an addition to the tea-table – the tea-kettle, provided with a baluster-legged stand with a spirit lamp or charcoal brazier beneath. Only the tea-caddy stayed firmly unaffected by the baluster curve, remaining an oblong or octagonal canister, usually with a bottle-like top and sliding base. Perhaps because chocolate was more fashionable in France than in England, French styles of baluster chocolate-pot were made.

Entirely French in conception, and almost always made by French silversmiths in England, were helmet-shaped jugs and ewers. Although they differed considerably in decorative detail, they were generally of similar form. Mounted on a circular, moulded foot, the body was divided by two ribs. The upper one followed the outline of the rim and spout and usually featured an applied mask or other decoration immediately below the spout.

19

The flying-scroll handle was sometimes cast as an arching cary-atid, while the bases were usually, though not invariably, enriched with applied work.

Applied detail and engraving were the two great decorative treatments of the Queen Anne period. Though much domestic silver was relatively plain, few important 'state' pieces were left unadorned. At the turn of the century there was a revival and a refinement of cut-card ornament. Delicate and detailed cut-out designs, sometimes enhanced with chasing, were applied round the bases of cups, ewers, bowls, pilgrim flasks (the great wine bottles used for cooling wine), coffee-pots, teapots, tankards, jugs and the tops of casters. Cast applied detail was another Huguenot trait soon adopted by all competent silversmiths.

Engraving on silver was of an exceptionally high order during the reigns of William III, Queen Anne and George I, and a number of very beautiful salvers and dishes have survived. In con-trast, some salvers and waiters were plain, or decorated with no more than a moulded or gadrooned rim and an engraved coat-of-arms or crest. Variety was sometimes achieved by the form only – square, circular, octagonal, hexagonal or multi-lobed. Shallow dishes with fluted edges, known as strawberry dishes, were made in various sizes from small saucer types to large bowls, some nine or ten inches in diameter. These, too, might be left plain, or delicately chased or engraved within each of the flutes.

The reign of George I saw the new age of the dining service. Plates and dishes in silver were nothing new, but now there were also soup tureens, sauce boats, and knives, forks and spoons made *en suite*. Forks in England had been rather late arrivals (those made prior to 1690 being very rare indeed). They were, however, included among the dinner-table wares of the early eighteenth-century home. About the turn of the seventeenth century, the trifid ends of spoons and forks became rounded off to the shield top, with a flattened stem and a rat-tail down the back of the spoon-bowl. Forks were sometimes two-pronged, usually three-pronged. During the reign of Queen Anne, the shield top was replaced by the round end, known as Hanoverian, but still with a plain rat-tail. Hanoverian remained the favourite pattern of flat-ware until superseded by Old English in the later eighteenth century and by more decorative patterns during the Regency.

Rococo was of French origin. It probably takes its strange name from *rocaille*, and was, indeed, an asymmetrical fantasy of rocks and marine creatures, flowers and shells and scrolls, leaping dolphins and foliate fronds.

About 1750 there was another revival of chinoiserie, this time executed in repoussé designs and in pierced work. It was an aptly popular fashion for all kinds of tea-table silver. Many a caddy and sugar-box was chased with robed figures, oriental flowers and gabled houses in the Chinese taste. As often as not, the chinoiserie designs were inextricably mixed with the scrolls and shells of the rococo.

During the 1760s pagoda-like roofs, Chinese figures and temple bells appeared on the elaborately-pierced basket epergnes used as table centrepieces on formal occasions. The bridges, coolie figures, palm trees and strange plants associated by the English silver-smiths with Chinese art were used with considerable delicacy for the pierced baskets and epergne stands as a contrast to the cherub-mounted, scrolling branches and shell- and flower-crusted rococo epergnes. Even pierced salts with cut-glass bowls were made in that style about 1760.

By the 1760s, even the most eager rococo-ists were tiring of asymmetry. Some silversmiths tended to look again across the Channel and to formalise silver in the French manner once more. Tureens were made shallower, with wavy rims and finials in the form of fruit or vegetables, rather like those made in porcelain. Sometimes ripple-fluted effects were achieved. On occasion, perhaps fostered by Horace Walpole's Strawberry Hill home, there was silver made in the Gothic style. The silver of the late 1750s and the 1760s was silver in a transitional style.

For several years London society had been eloquently discussing and avidly following the excavations of classical sites at Palmyra, Baalbek, Rome and Herculaneum. Artists and architects visited the sites for themselves, and returned with sketches and scale drawings and plenty of ideas to put into practice. Among them was the young Scottish architect, Robert Adam. The acknowledged aim of the neo-classicists was to draw on 'the most elegant ornament of the most refined Grecian articles'. Laurel wreaths and festoons, anthemion, palmette and scroll borders were neat and re-strained after the contorted cult of rococoism. The stone urn and

the vase provided an elegant new shape for silver – so few metal-wares had been uncovered in the excavations anyway.

A development of engraving called bright-cut was particularly suited to the Adam designs that soon came to be made in silver. Fluting was equally suitable for echoing the slender marble pillars and pilasters beloved of Adam, and it was also well suited to the new stamping processes which were being used, especially in Sheffield, for making candlesticks.

The very simplicity of the vase and the oval made them ideal for domestic silver such as teapots, tea-urns, sugar bowls and swing-handled baskets, soup and sauce tureens as well as for the ubiquitous cups and covers that were presented as race trophies and on every possible civic occasion as well. The classical column was tapered, and topped with an urn finial for candlesticks and candelabra. Beading and reeding were the most favoured border ornaments. Piercing was as restrained as the regular galleried frets of Chinese Chippendale, though the epergne makers, now constrained by the oval and formal classical motifs, did achieve scroll and leaf-pierced borders, and added interest to pierced boat-shapes by using deep-blue glass liners.

The success of Adam and the neo-classicists lay in their elegant, delicate designs, but Wyatt and Henry Holland had more grandiose tendencies, while by 1800 even the King voiced an opinion that 'the Adams have introduced too much of neatness and prettiness'. In silver, however, the 'snippets of embroidery' had already started to give way to a grander style by the 1790s. There was more pronounced and even applied decoration overlaying the simplicity of the Grecian. Festoons, once only bright-cut, were now chased with a Roman majesty; small applied medallions, modelled of course on classical lines, were used particularly by Fogelburg and Gilbert on jugs and teapots. Lion masks once again appeared at the knuckles of sauce boats and footed tureens; bold leafage, ovolos and scrolls in relief, and reed-and-tie borders began to supersede beading and simple reeding. Once again, the tide of taste was changing, and sweeping in with the tide, urging it fast ahead, was the Prince of Wales, the last and most powerful of dilettanti.

'Prinny' was an enthusiastic and lavish patron, though his genius and taste were not always either elegant or wise. He had grandiose schemes for building and furnishing, but changed his

mind with infuriating regularity. In Rundell & Bridge he found an ambitious firm of goldsmiths who were ready to cater to his strangest whim. They commissioned artists and sculptors to produce designs for plate. Now all sign of Adam grace vanished. 'Massiveness', boomed C. H. Tatham, 'is the principal characteristic of good Plate,' and 'good Chasing . . . a branch of Sculpture.' At Rundell & Bridge's behest men such as Tatham, John Flaxman and Stothard turned the silversmith into a vehicle for producing sculpture in silver.

A most distressing habit, in the eyes of the modern collector at any rate, was the 'improving' of old pieces of plain silver by the addition of a revived rococo chasing. This was not only a Victorian weakness, and there are records both of added decoration and alterations made in the period between 1818 and 1830. It was not a practice intended to defraud, but merely to conform to fashion.

Machines were also being put to work. In Birmingham and Sheffield in particular stamping presses were turning out copies of handmade pieces. Sheffield candlesticks were, indeed, good examples of silver made by stamping in sections, assembly and loading. It was later, mostly in the 1830s and after, that there was the temptation to use a base from here, a stem from there, a socket from another design.

The London silversmiths were still, on the whole, hand craftsmen, but they, too, were caught in the net of grandiosity for its own sake. Storr and Smith, who both survived the Regency by many years, were masters of their craft and essayed many pieces – especially after both had broken with Rundell & Bridge – that hinted at the trends the craft might have taken if the silversmiths had been left on their own. Their virtuosity ranged over every style – from noble Roman and elegant Greek to an almost modern simplicity of curves and plain surfaces.

Sheffield Plate was introduced as a substitute for silver and to provide a wider public with pleasant and decorative wares. In 1840 the invention of electroplating meant yet another commodity with which silver had to compete. The early Victorian period, with its huge industrial upheavals, its quickly rich and multiplying poor, changed the face of Britain. The Victorians did not, however, stifle craftsmanship. They extolled it. Two years before Queen Victoria came to the throne, a 'Select Committee on Arts and

Manufactures' was appointed by Parliament. It strongly recommended forging links between fine and applied arts and industrial production. 'It equally imports us to encourage art in its loftier attributes', the committee sententiously reported, 'since it is admitted that the cultivation of the more exalted branches of design tends to advance the humblest pursuits of industry.' No exhibition, no laboured patronage, could reassemble the shattered fabric of a broken tradition, in which neither design nor craftsmanship followed its original course.

Nevertheless, it must not be supposed that nothing of interest or aesthetic merit appeared in Victorian and later times. Arising directly out of the Great Exhibition of 1851, incidentally, was the foundation of what is now the Royal College of Art in London – one of the earliest of the great art schools of the world. In the intervening 120 years the art schools and colleges have made an important contribution to the higher standards of craftsmanship and design which, in recent years, have become evident in every branch of the applied arts. It is significant that a large proportion of the silver objects of the present century has come from the art schools in London, Birmingham and Sheffield.

The Arts and Crafts Movement of the 1880s and the fashion known as Art Nouveau which flourished around the turn of the century have both left their mark in English silver. In recent years the attention of collectors has turned increasingly to this period and the Cymric silverware produced by Liberty's, for example, has acquired new interest, after languishing in unfashionable oblivion for half a century.

Not for nothing has the word 'sterling' come to be synonymous with high quality and reliability. Both pressure from successive governments and the desire of the trade itself have conspired to maintain the standards of English silver at the highest level. This high standard was always jealously guarded and regulations for the control of quality were very strictly enforced. Silver items sent to the assay office for testing and hallmarking were subject to rigorous tests and, if found wanting, would promptly be destroyed. The penalties for lowering the standards were severe. The result is that the collector of English silver can be reasonably sure that what he collects is sound intrinsically as well as aesthetically.

The system of hallmarks enables the collector to identify the

date and place of manufacture and, in most cases, the manufacturer as well. This age-old practice of 'signed' silver is a good thing in many ways, not the least being the protection which it affords the customer; but in one respect it has created a somewhat artificial demand for the work of certain craftsmen. The fact that a piece can be assigned to Paul de Lamerie, Paul Storr or Hester Bateman automatically boosts its market value, irrespective of aesthetic or antiquarian interest: this deplorable tendency has been fostered by the trade in general and by some sections of the Press in particular.

As a result there have been rather disturbing cases of the faking of hallmarks, usually by grafting genuine hallmarks (taken from some relatively insignificant item) on to larger articles. This is done very skilfully but the faint solder marks can usually be detected by breathing hard on to the hallmarks, when the line of the joint should become discernible. The Trades Descriptions Act of 1968 gives the purchaser a measure of protection in such cases, but 'let the buyer beware' should be one's watchword. Where a silver article consists of two or more parts make sure that the hallmarks on the component parts match each other exactly. Occasionally one will come across items in which the hallmarks are irregular, yet the article is perfectly authentic. This points to the practice, prevalent in the eighteenth century, of evading the heavy duty on silver, and even the larger and more reputable companies were not averse to this when they could get away with it. If in doubt about an item a second opinion can always be sought before committing oneself to purchase.

Caring for Silver

Tarnish on silver is caused by sulphur in the atmosphere combining with the silver itself and forming silver sulphide. Tarnish is best countered by using silver, washing it regularly and polishing gently with a soft cloth. Silver left stored in cupboards or drawers usually gets much more tarnished than silver used every day.

Silver takes a good polish, but all polishing has the effect of removing metal in the process. After many years this becomes appreciable, and it may also have the sad result of obliterating details of decoration, engraving and, of course, the hallmarks. It is a good idea to keep one's thumb over the marks when cleaning.

From time to time, however, all silver needs polishing to bring up its fine lustre. Rouge requires some skill in use, and though for the professional silversmith it is undoubtedly still the best polish available, in the home it is messy and difficult to use.

It was in 1839 that a Midlands chemist, Joseph Goddard, took the first commercial step in producing a safe and simple polish, which was non-mercurial. Plate powders of the type he invented, plus the more convenient, liquid plate polishes and creams, remain the basic silver-cleaning equipment of many homes; indeed, it took more than a century before Goddard's own descendants brought out the revolutionary dip methods of cleaning plate. These have certain special advantages, in that they remove even well-established tarnish quickly and easily, though they do need polishing after drying.

Most polishes now contain some form of protective coating that

helps to keep the silver bright for much longer than previously, thus cutting down the need for cleaning to only three or four times a year. One of the newest and cleanest methods for the user is foaming polish, which is applied with a damp sponge and at once lathers and attacks the tarnish. Its action is very gentle, and blackened clothes and dirty hands are avoided, the lather and tarnish being rinsed off together in warm water.

Impregnated cotton polishing-cloths and a good soft chamois leather help to maintain the polish and lustre of silver between regular cleaning sessions. Brushes for penetrating crevices and chasing should be of good quality soft bristle. For little-used silver, storage bags, nowadays treated to resist tarnish, and special tissue papers are available.

Of the products that form a protective layer the main ones are rhodium (of the platinum group) which forms an untarnishable but rather bright plating on the silver, and silicone which is effective for three to four years and which can have ordinary polishes applied on top.

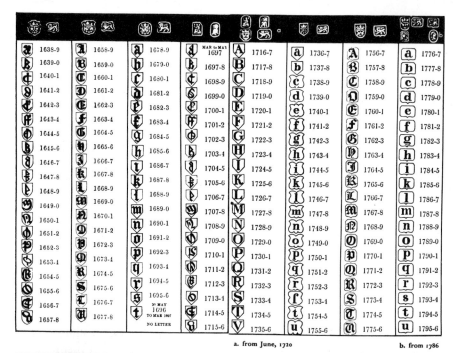

a. from June, 1720

b. from 1786

c. from 1821

d. from 1837

e. Queen Victoria duty mark to 1890

Provincial Marks

ENGLAND

Birmingham

Sheffield

Chester

Exeter

Newcastle

Norwich

York

Hull

Bristol

Above is the complete list of assay-office marks from 1638–1916.

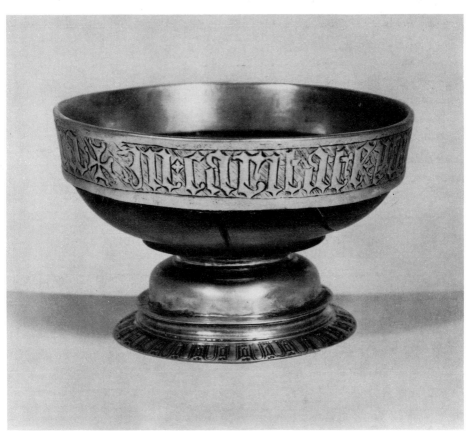

Plate 1 Mounted bowls, cups and jugs were popular from early medieval times. Wood – especially the spotted maple – pottery, ostrich eggs, mother-of-pearl and rock crystal, serpentine and rare porcelain from the east were all made into useful or ornamental vessels by the addition of silver or other mounts. Relatively large numbers of medieval mazer bowls survive, the band around the lip often carrying inscriptions, and the base with a medallion or 'print', perhaps engraved with a religious emblem. This mazer of fifteenth-century date is $4\frac{3}{4}$ in. in diameter and has a later foot of about 1620.

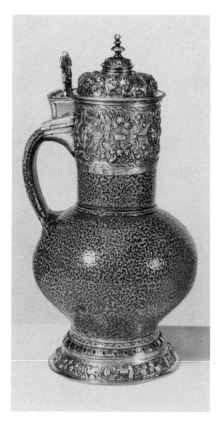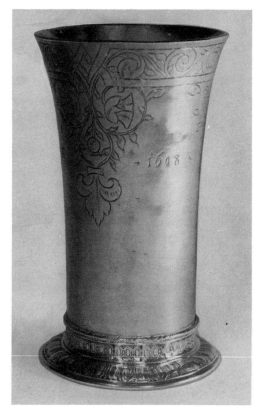

Plate 2 This typical example of tigerware, mounted in silver, of 1577, 10 in. high, bears the London hallmarks and the maker's mark, WC, a grasshopper below – probably for William Cocknidge.

Plate 3 The beaker with its tapering sides and slightly everted lip was, until the coming of glass at the end of the seventeenth century, one of the most universal of all drinking vessels. Large silver beakers, between $5\frac{1}{2}$ and $6\frac{1}{2}$ in. high, were usual in the James I period, and there was an almost uniform pattern of engraved arabesques and strapwork with pendant motifs around the top, and stamped ovolos and similar formal decoration round the spreading rim foot. This beaker with its stylised scroll, thistle and strapwork ornament is $5\frac{3}{4}$ in. high, weighs 9 oz. 17 dwt. It is engraved 'Mychaell Hampe 1608', for the Mitchell family of Hamp, Somerset. It was in fact made in 1608, by a maker using the mark GC, with a mullet above and below.

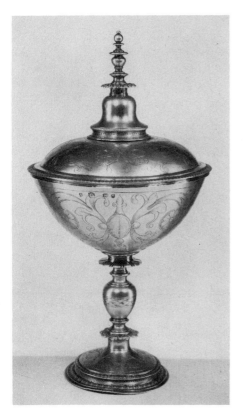
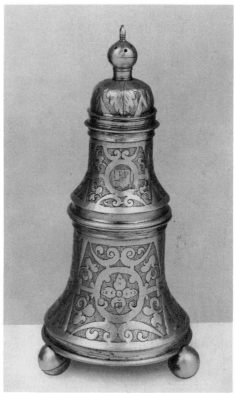

Plate 4 Elizabethan ornament, always derived from Renaissance designs, could be crustily embossed and chased or extremely simple, a series perhaps of engraved lines or 'hit-and-miss' hyphen-like ornament as seen on many Communion cups of the period. The Hutton Cup, made in 1589, has its spreading bowl and domed cover boldly engraved with formal sprays of scrolling foliage and flowerheads in most orderly array. By tradition the cup was a present from Queen Elizabeth I to her god-daughter Elizabeth Bowes.

Plate 5 Less ostentatious than the architectural great salt of tradition was the late Elizabethan bell salt which came into fashion about 1590. Arranged in three sections, the lower and middle parts bell out below the domed upper part which contains a small perforated section screwed into the top. The two lower sections contain shallow depressions for salt, and the whole salt stands on three ball feet. Most of these salts were decorated with chased scrolls and strapwork on a matted ground – as the one illustrated here, though simpler engraved bell salts are also recorded. The salt shown is 8¾ in. high, weighs 10 oz. 7 dwt., and was made in 1599.

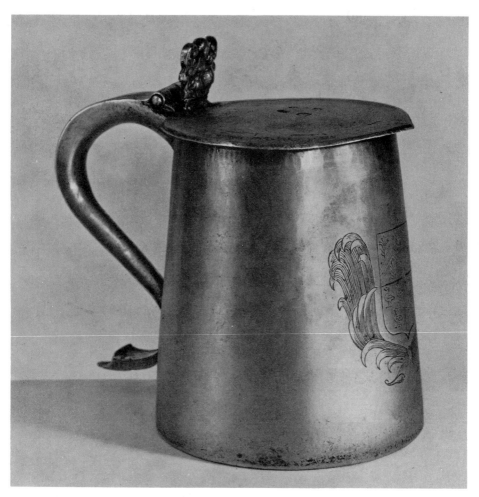

Plate 6 This tankard is a survival of Elizabethan renaissance style. The thumbpiece is in the form of a winged female figure. The handle is a plain bold scroll, the cover is flat and peaked, and carries the maker's mark, RP, the London hallmarks and date letter for 1638.

Opposite

Plate 7 Until the beginning of the eighteenth century silver goblets were still made in fairly large quantities, sometimes decorated with engraving or repoussé chasing, sometimes plain except for perhaps an engraved coat-of-arms in a plumed cartouche. On this wine cup, $5\frac{3}{4}$ in. high, the arms are in a crossed laurel wreath. The cup, which weighs 4 oz. 10 dwt., was made in 1639. The maker's mark appears to be a bird with an olive branch above initials, one of which is T.

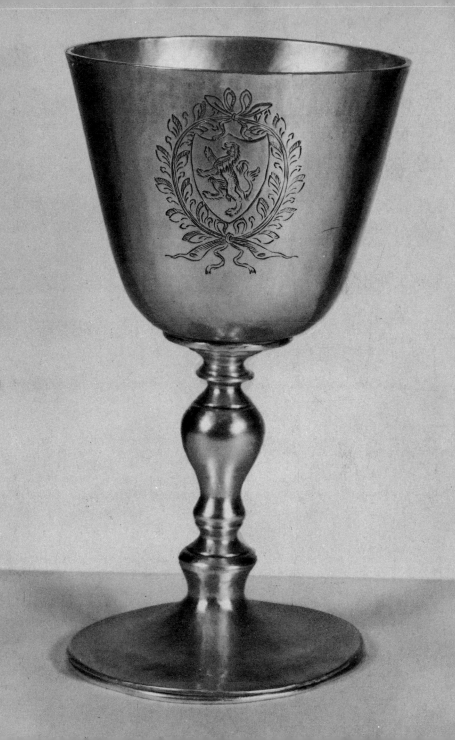

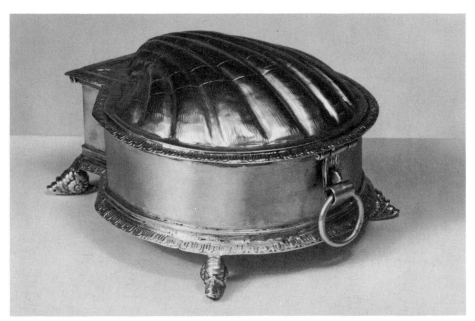

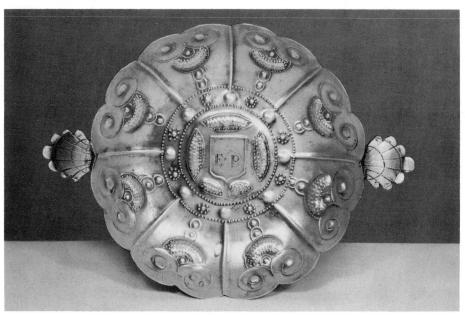

34

Plate 8 There is in the Ashmolean Museum at Oxford an unmarked, silver-mounted box, its lid formed of an actual scallop shell. Several of these small boxes of silver, usually termed spice or sugar caskets, were made during the early years of the seventeenth century; the earliest and richest in fact dates from 1598 and is in the collection of the Middle Temple in London, its sides beautifully chased with scrolls, flowerheads and strapwork of a high order. The top is typically chased to represent a scallop shell and the four feet are also formed as shells. More usually, as on this box of 1612, the sides were plain and the feet were either shells, or, as here, snails. This box is 5½ in. long and weighs 12 oz. 2 dwt.

Plate 9 More than half the little saucer-dishes made between 1630 and 1640 appear to have been the work of William Maundy, and his business was apparently continued by Thomas Maundy – two of the few silversmiths of the periods whose marks have been identified. This saucer was made by William Maundy in 1634, is 5½ in. in diameter, but weighs only 3 oz. 5 dwt.

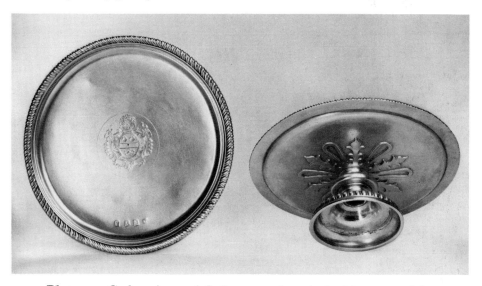

Plate 10 Gadrooning and fluting were the principal keynotes of the later Dutch baroque, a style wholeheartedly accepted by the London silversmiths. A seventeenth-century newcomer to the silversmith's range had been the salver, often made to match tankards or porringers to save 'the Carpit (i.e. tablecloth) or Cloathes from drops'. The uses for salvers were, in fact, legion, and they remained a stable line for the silversmith throughout the eighteenth century. Early salvers were often provided with a detachable trumpet foot. This salver, by Robert Cooper, 1691, has foot and border gadrooned.

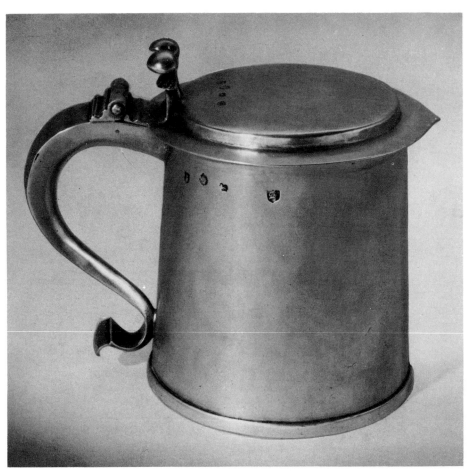

Plate 11 Tankards were made in silver holding as much as three or four pints, and one massive example of 1690 is recorded as holding no less than six pints. Average tankards, however, are usually about 6 in. high. The Charles II type, with its plain body, usually only relieved by an engraved coat-of-arms, its flat cap cover with a peaked front, its bifurcated scroll or corkscrew thumbpiece, scroll handle and plain rim foot set the style until the eighteenth century. This example of 1661, by a maker marking with an Orb and Cross, weighs 25 oz. and stands 6 in. high. Note the typical placing of the hallmarks.

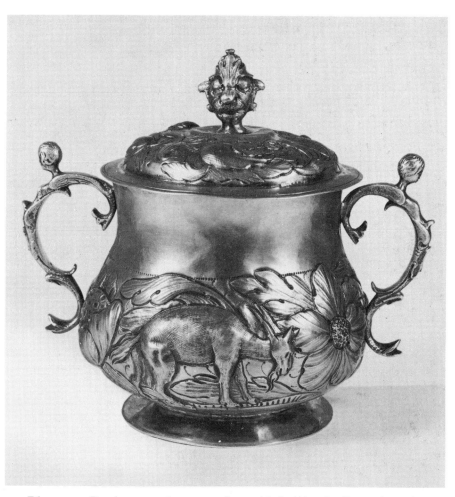

Plate 12 Porringers and covers, often with bulging bodies embossed with bold naturalistic chasing, are typical of the domestic silver of the Restoration period. The Janus-like finials often show tragic and comic masks, while lion and unicorn motifs were also popular. This cup, formerly in the possession of the Coldstream Guards, is repoussé chased with a lion on one side, a goat on the other, amid flowers and foliage. It is $7\frac{1}{2}$ in. high, weighs 29 oz. 10 dwt., and was made in 1663. The cover, by the same maker, H.G., dates from 1661.

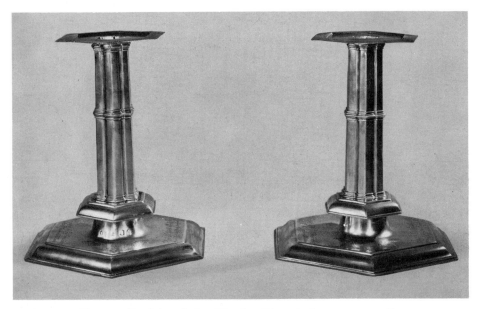

Plate 13 The candlesticks of the Charles II period were generally columnar, with square or hexagonal bases, and broad drip pans at the tops. As the century wore on, drip pans became smaller and the columns were fluted. Sometimes the bases were enriched with acanthus leaf or other embossed chasing. In size, candlesticks were from about 8 in. to as much as 12 in. high, and sets of two or four were not uncommon. The pair shown belongs to Hereford Corporation, and was made in 1666 by one of the most prolific and best London makers of the period, who used a mark of a crowned S, often ascribed to Charles Shelley. The sconces are by another maker and date from 1670.

Opposite

Plate 14 Silver for display was usually influenced by the richly overall-chased Dutch designs. Even firedogs and furniture were made of silver, while garnitures for the mantelpiece, in the style of pottery jars and vases, were another silver luxury. Ovoid jars with domed covers, usually known as ginger jars, were the most usual form for this decorative silver. This jar, from a pair made about 1675 (maker's mark, IB, with a crescent below) is 10½ in. high and is richly and finely embossed and chased with an amorino on either side playing a trumpet in a forest of scrolling foliage on a matted ground. Others, usually a little larger, were embossed and chased with alternating lobes and leaf strapwork, and might be festooned with fruit and floral garlands around the domed, bud-finialled cover.

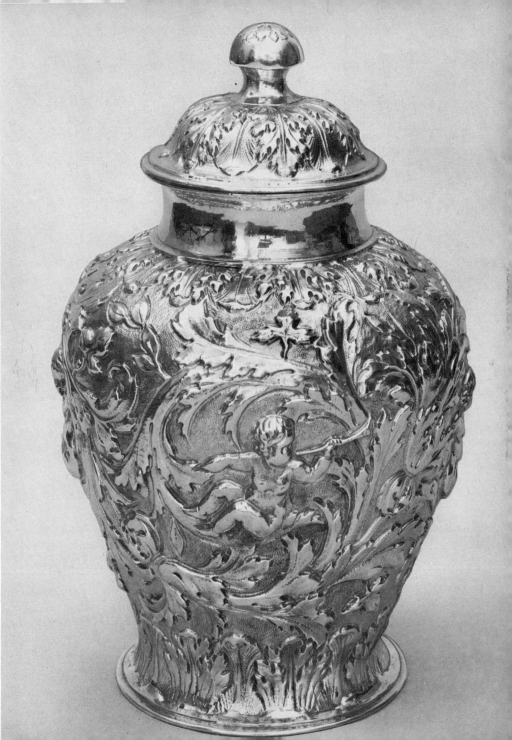

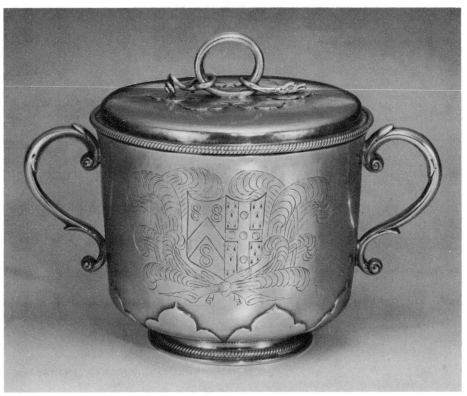

Opposite

Plate 15 In the years of silver shortage, cut-card decoration served the purpose of strengthening handle and foot joints as well as being ornamental, but it was also much used on relatively heavy pieces of silver – as on this beautiful oval casket with cut-card decoration above the cast feet and round the looped-snake handle. The box, which is 8 in. long and weighs 20 oz. 15 dwt., was perhaps for sugar.

Plate 16 This fine, heavy cup and cover, in the almost straight-sided baroque style that succeeded the rather florid ogee-shaped bowls of early Charles II porringers, has the maker's mark, HW, in a shaped punch, on both body and cover. It is heavy, weighing 28 oz. 2 dwt., and is 6 in. in height. On style it can be dated to c. 1680.

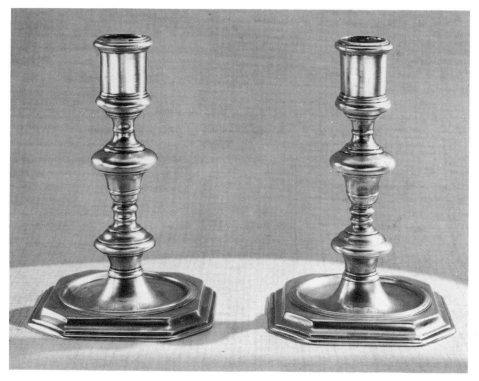

Plate 17 The earliest known baluster candlesticks were the work of Pierre Harache in 1683, but within two years London makers had followed suit with baluster sticks, on moulded octagonal bases with slightly sunk centres, knopped stems and cylindrical sockets. Baluster candlesticks of this type, usually between 5 in. and 7 in. high were made in pairs, fours, and sixes with little variation until about 1718. The pair shown above were made by Ralph Leeke in 1690.

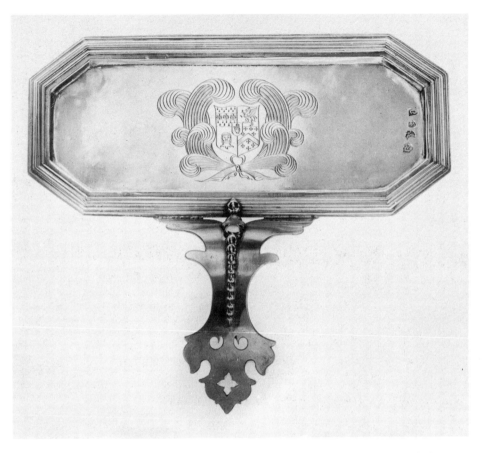

Plate 18 The reeded border, the pierced back handle with its beaded rib and its engraved coat-of-arms in a plumed cartouche all corroborate the evidence of the hallmarks which show that this snuffer tray was made by Francis Garthorne, a leading London goldsmith in 1678. The tray is accompanied by a pair of undated contemporary snuffers by another maker. It is rare to find tray and snuffers by the same maker. The snuffers were scissor-like implements, with a box at the axis, used for wick-trimming.

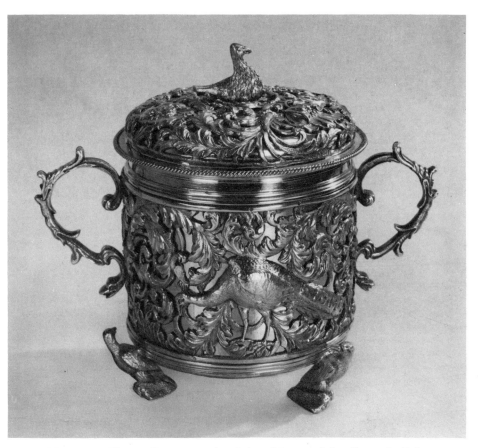

Plate 19 The earliest example of sheathing a plain silver-gilt lining with a casing of pierced and chased silver is dated 1669. This rare and interesting style was followed even as late as about 1685, however, when a silversmith, probably Thomas Issod, made this cup and cover, from the collection of the Goldsmiths' Company. The inner drum is silver-gilt, and the outer sleeve silver-pierced and chased with foliage and birds in the Dutch manner, with a peacock on one side and a turkey on the other.

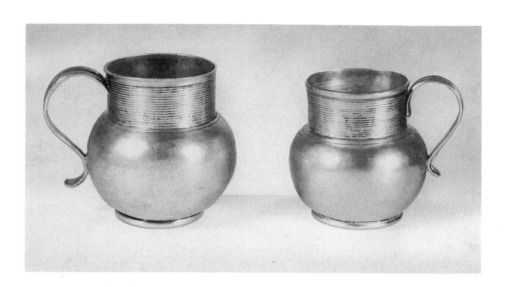

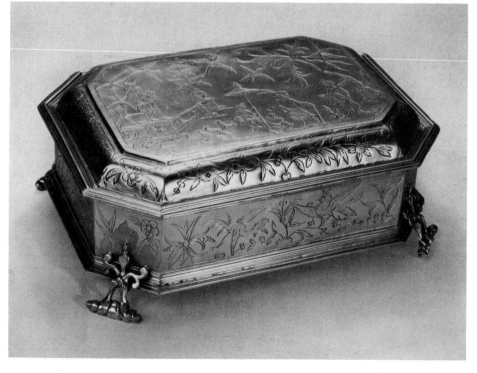

44

Plate 20 Most functional mugs and cups were plain – even without arms, suggesting that they were the silver of the middle classes rather than the gentry, and initials or at best a monogram were the usual key to ownership. These two small mugs have the typical hand-raised bulbous body on a rim foot, reeded neck and fluted scroll handle. The larger, 4 in. high, was made in 1688, the smaller, 3½ in. high, dates from 1683.

Plate 21 Since toilet sets were fashionable, it is not surprising that the fashion for chinoiseries should have affected them, and brushes, caskets, boxes and bottles were often engraved or flat chased with charmingly naïve dreams of the land from which tea, spices and porcelain were now arriving in increasing quantities. This octagonal casket from a toilet set of 1683, shows typical birds, flowers and hunters.

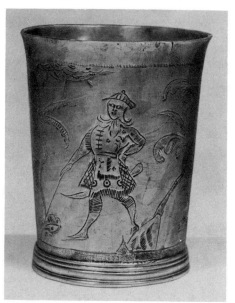

Plate 22 Beakers followed forms as traditional as mugs, and were made in all sizes and also as barrel-like pairs – double beakers. Beakers of tapered cylindrical form on a moulded foot were made throughout the length and breadth of the country and even survived the arrival of glasses and better pottery. Usually about 3 or 4 in. high, decorated styles followed the current fashion for engraving, chinoiserie flat chasing, acanthus embossing and the like – as this small beaker of 1688 with its figure of a strutting Chinaman among sketchily worked trees, plants and birds. The plain beaker was made ten years later, in 1698, by George Garthorne, who by then had to use the higher Britannia standard silver for his work.

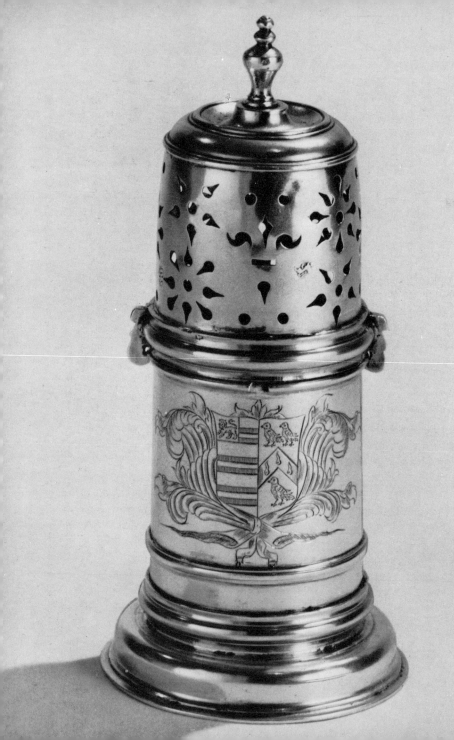

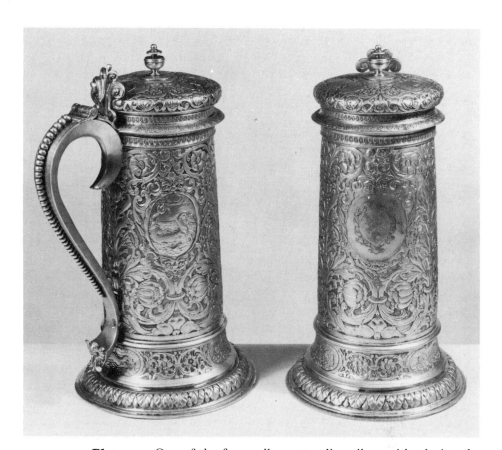

Plate 24 One of the few really outstanding silversmiths during the Charles I and Commonwealth periods was a maker using a hound sejant as his mark. His work is unexceptionally fine, and these two flagons from Thirkleby, Yorkshire, are superb examples of mid-seventeenth century chasing in the best Dutch style. Each flagon is 10 in. high and has panels of dolphins and sea-monsters amid scrolling foliage and flowers. The panel on the front is engraved with the arms of Tyssen, a family of Dutch-born merchants. Made in 1646, the flagons weigh 73 oz.

Opposite

Plate 23 Large casters were made in the late seventeenth century in sets of three, one large caster for sugar, and a pair of smaller ones for pepper and dry mustard. Keeping the pierced top in place when inverting the caster resulted in the rather clumsy bayonet joint. Piercing was usually rather coarse, and the moulded rim foot was frequently also pierced out en suite with the top. This straight-sided caster, made in 1690, bears the maker's mark BB.

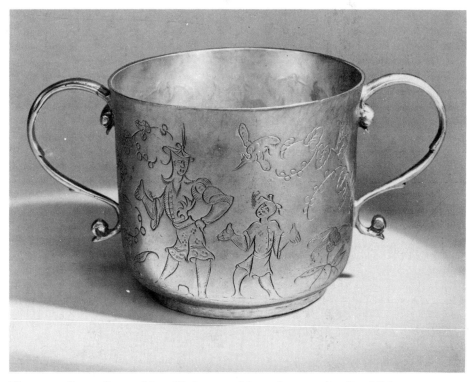

Plate 25 Some silversmiths still clung to older styles, even in 1691. This small two-handled porringer, engraved with chinoiseries, features the rather slender scroll handles that superseded the even spindlier caryatid handles. By now, however, most porringers, with or without covers, were coming to be decorated with half-fluting around the lower part of the body, the upper part being slightly everted and girdled with a band of cording. Between the fluting and the rib an embossed and chased baroque cartouche for crest or initials was often provided.

Opposite

Plate 26 Tea, coffee and chocolate, all introduced to England about 1650, had more impact on silverwares than any other drink. At first the silversmiths were undecided how best to shape the pots for the new beverages. For coffee and chocolate they adapted the cylindrical form of the tankard and flagon, tapering the body, and adding a straight spout and a conical cover. Indeed, one of the first teapots known also followed this form, although a pattern based on the Chinese wine-pot with a curved spout really set the style for teapots. In this conical coffee-pot by Andrew Raven, made in 1700, cut-card work gives decorative detail at the junction of the sockets for the D-shaped handle which is at right angles to the rather unimposing straight spout.

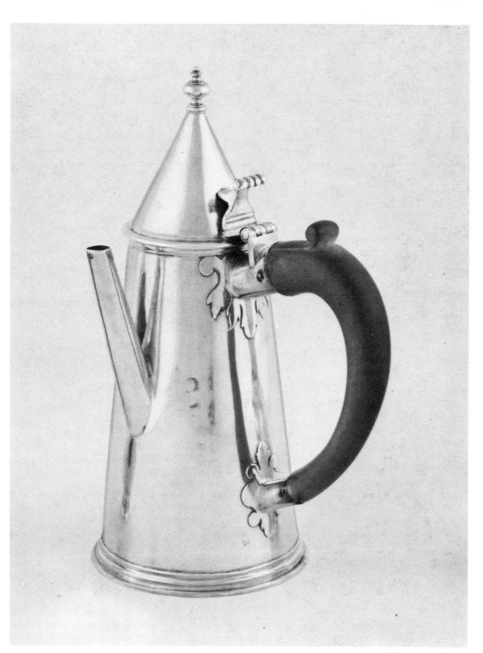

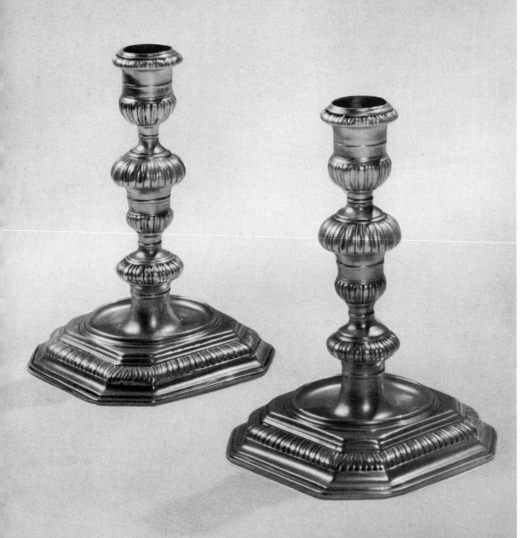

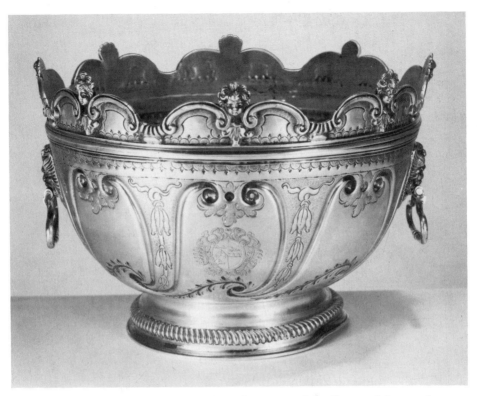

Plate 28 Isaac Dighton, a maker who seems to have favoured the panels enclosed by spiral scrolls on more than one punch bowl, made this one in 1699. It is 11 in. in diameter, weighs 55 oz. 18 dwt. and is now at Temple Newsam House, Leeds.

Opposite

Plate 27 The gadrooned candlesticks dated 1699, are a late example of the baroque style by Pierre Harache, though gadrooning had more or less gone out of fashion altogether by about 1705. A variation of the gadrooned baluster stick was that with small applied lion masks at the shoulders. From the same period date a number of figure candlesticks, with fluted sockets upheld by kneeling blackamoors or draped female figures and even the straight columnar type with fluted and reeded stem and octagonal base survived.

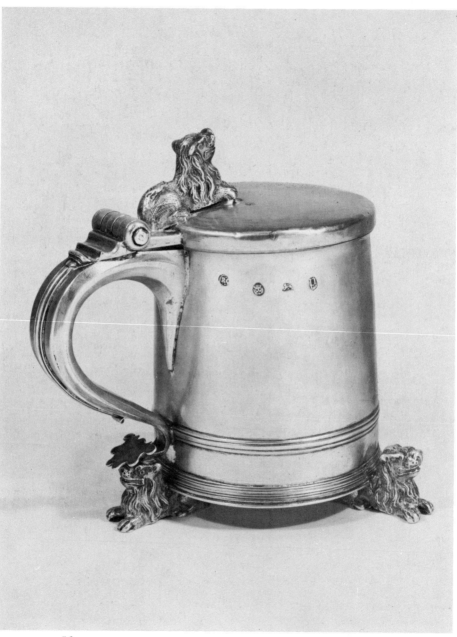

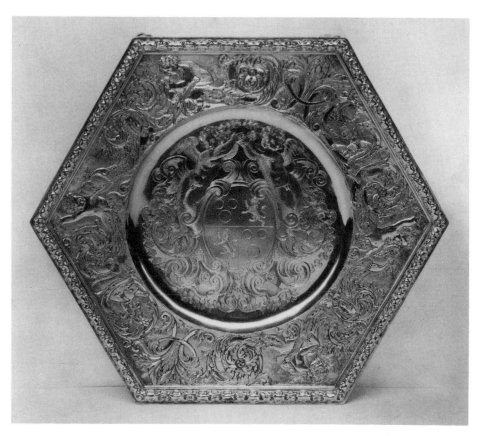

Plate 30 Benjamin Pyne, a prominent and prolific London silversmith, while objecting to Huguenots opening workshops in London, employed a French design for the beautifully flat chased and engraved ornament of his hexagonal dishes of 1698 – and probably a French craftsman to do the work as well. The dishes, with a border of cupids, animals and foliage, have a most elaborately engraved coat-of-arms contained in a scrolling, foliate and cupid-surmounted cartouche.

Opposite

Plate 29 A rare instance of Scandinavian influence on English silver at a time when Scandinavian silversmiths were themselves beginning to copy English tea and coffee silver, is this large tankard of 1692 by Robert Cooper. As well as the lion couchant feet and thumbpiece, the tankard shows Scandinavian influence in the broad reeded bands at and a little above the base, and in the slightly domed cover. The front of the body carries a coat-of-arms of rather later date.

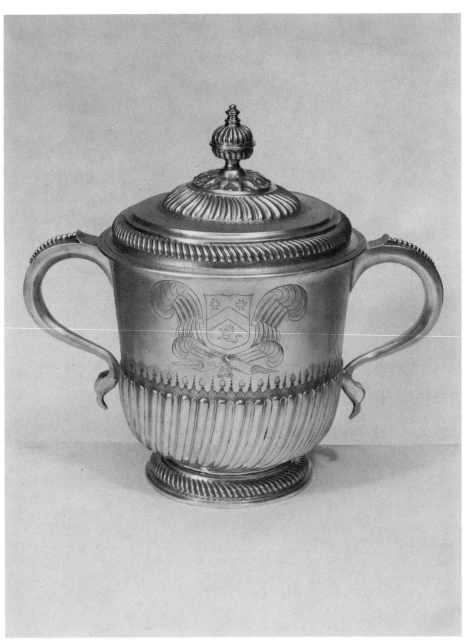

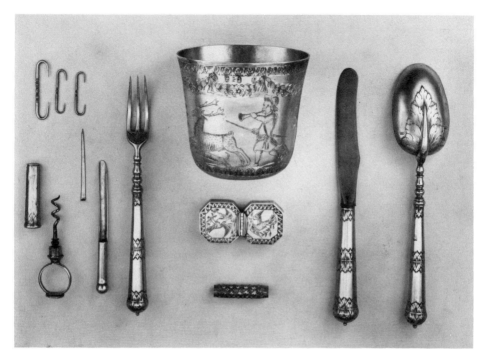

Plate 32 Even as late as 1763 when Tobias Smollett went on his travels to France and Italy, he took with him the necessities of gentlemanly living – linen, books and, not least, a modicum of silverwares. On all outdoor occasions, the travelling set was a useful pocket companion, and the most comprehensive included a beaker or tumbler-cup, knife, fork and spoon with detachable handles, double spice box for salt and pepper, nutmeg grater in its cylindrical case, apple corer, toothpick, and corkscrew. Spoons and forks of such sets were usually by specialist makers, and it is not unusual to find most of the pieces unmarked or only partly marked. In this set, which folds neatly into a green velvet covered block inside the tumbler, the cup is by Charles Overing, 1701, and is delightfully and typically engraved with a hunting scene. The three hooks may have been for napkins.

Opposite

Plate 31 While the Huguenots were slowly establishing themselves and their baluster styles, the English silversmiths continued to work in the baroque manner, though even they followed the French lead towards taller cups and covers. A scalloped matted band and punched motifs, however, betrayed the English makers, and while both English and Huguenot silversmiths used gadrooning extensively, beaded handles seem to have been a native motif. This cup and cover $11\frac{1}{4}$ in. high and weighing 46 oz. 8 dwt., was made in 1699 by John Sutton.

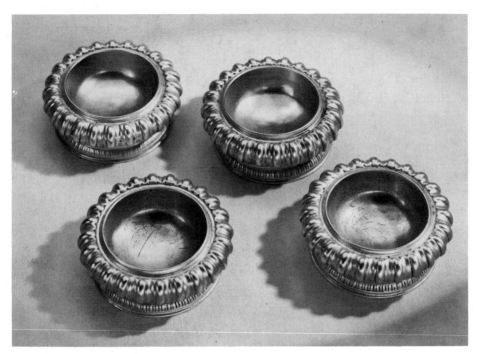

Plate 33 Salt, no longer the condiment of ceremony, still had its place at table, and the small trencher salt, often cast, was a pleasing feature of the dinner service. The taller, spool-shaped individual salts of the later seventeenth century were replaced by small, low ones, sometimes plain, sometimes decorated as here. A favourite style was the octagonal, with stepped moulded sides. These four circular salts, on gadrooned, moulded bases, have boldly fluted sides and circular wells. They were made by Edmund Proctor in 1701.

Opposite

Plate 34 Even without the mark of Pierre Platel, the silversmith who taught Paul De Lamerie his craft, this cup and cover is unmistakably of Huguenot origin. The applied strapwork, with its husks and guilloche ornament within spoon-like surrounds, the formal leaf cut-card on the cover with its fine finial, the harp handles and the somewhat elongated body all suggest Huguenot work. Note also the exceptionally fine engraved coat-of-arms. The cup was made in 1702.

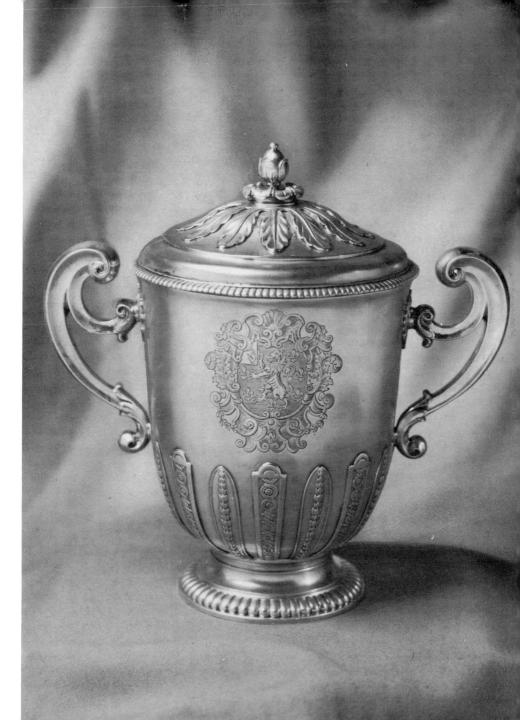

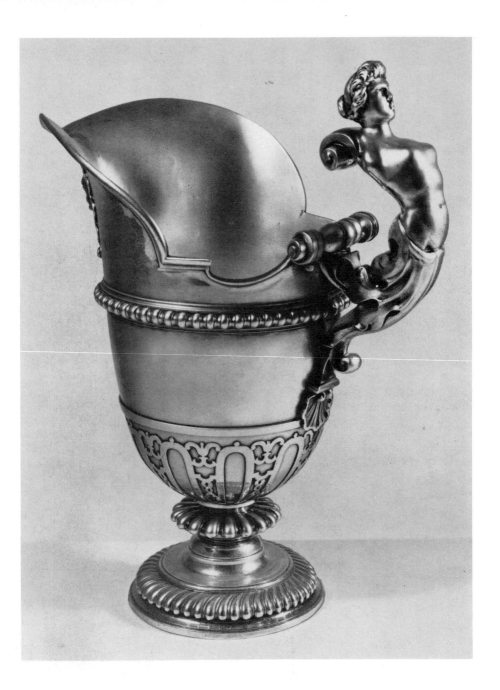

Plate 35 This superb example of the helmet-shaped ewer by Pierre Harache was made in 1703, and illustrates his mastery of modelling, of applied strapwork and use of a decorative mask in association with moulding and gadrooning. The figure handle was a favourite with Harache, as was the mask of Diana – on a shell below the shaped, moulded lip. The ewer is 12 in. high, and weighs 69 oz. 11 dwt. It bears the arms of Methuen engraved in a most elaborate baroque cartouche.

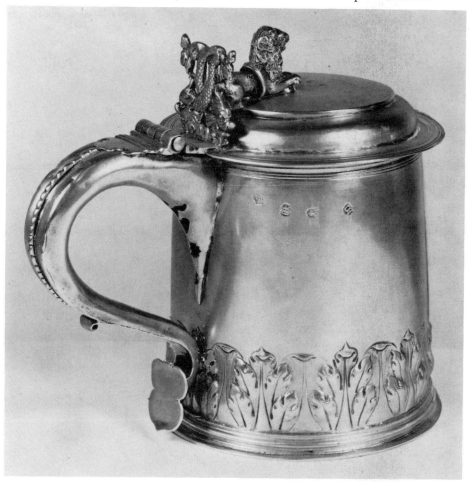

Plate 36 This tankard of 1677, 7¾ in. high, follows the typical seventeenth century style, though the silversmith (known only by his mark, IA, in a beaded oval) has been influenced by the continental baroque style with its emphasis on cast chased ornament.

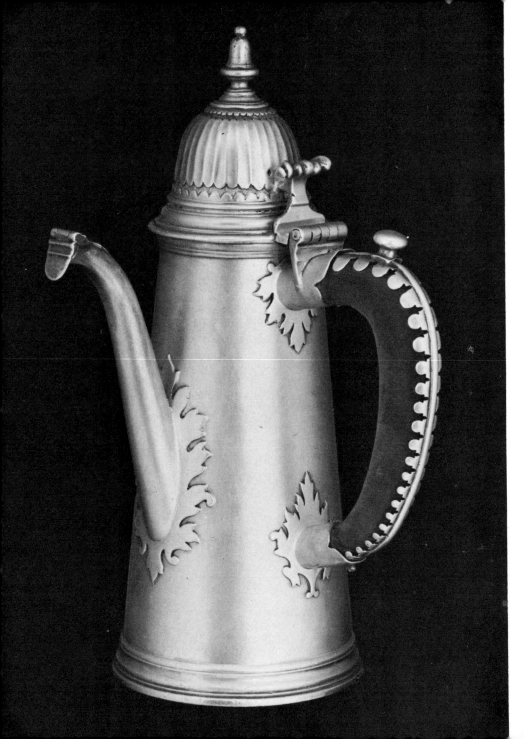

Plate 37 Soon the silversmiths mastered the style that was to dominate coffee and chocolate-pot design for the next two decades. They retained the slightly tapered, cylindrical body, but gave them a new grace and dignity with a curved spout, sometimes provided with a hinged cap, and by using a high-domed cover topped with a baluster finial. The handle was set at right angles to the spout, the continental practice of using a straight, horizontal side handle not generally finding favour in England. This coffee-pot of 1701, just under 10 in. high and weighing 25 oz. 12 dwt., was made in London by Anthony Nelme. The leather-covered handle is decorated with a silver strap, and the high-domed cover with acorn finial is fluted and matted in the English baroque manner.

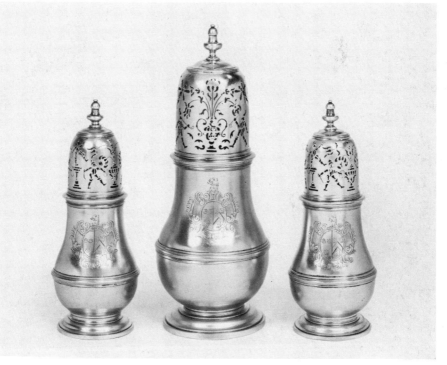

Plate 38 A set of three Queen Anne silver-gilt pear-shaped casters, each on circular moulded foot, with ribs round the bodies and high domed covers pierced with figures, vases of flowers and foliage, with urn finials, engraved with a coat-of-arms in a scrolling foliage cartouche – 6½ in. and 8¾ in. high, by David Willaume (33 ozs.)

61

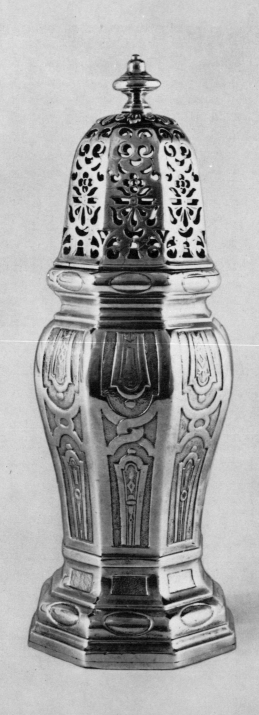

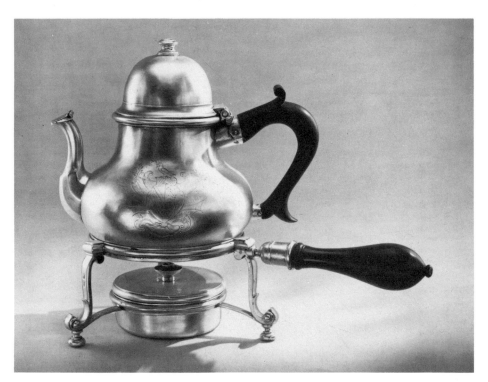

Plate 40 Early teapots were usually small, probably due to the extremely high cost of tea. This pear-shaped teapot, quite plain except for a coat-of-arms in a baroque cartouche engraved on the side, has a faceted swan-neck spout with hinged cover, very high-domed cover and turned wood-scroll handle. It was made by Benjamin Pyne in 1707. Of the same date is the tripod stand on scroll and bun feet supporting a circular lamp, and with wood side handle. The stand was made by Isaac Liger. The pot and the stand are 8½ in. high overall.

Opposite

Plate 39 The baluster form was early adopted for the sugar caster, especially by silversmiths of Huguenot origin, who also favoured applied or flat chased ornament and designed intricate, pierced patterns for the tops. This large caster, 8¼ in. high, is from a pair by Lewis Mettayer. The outward-curved baluster form is eight-panelled and chased with strapwork on a matted ground. An unusual feature is the method of securing the scroll-pierced cover, a slip-lock being used to obviate the usual clumsy bayonet clamps. The casters, made in 1705, are each engraved on the bases with their original weights – 20 = 8 and 22 = 17 – instancing the heavy silver of the period.

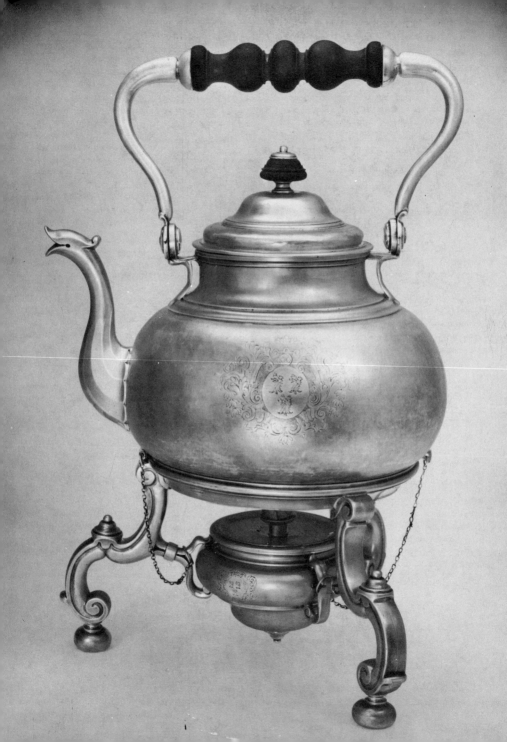

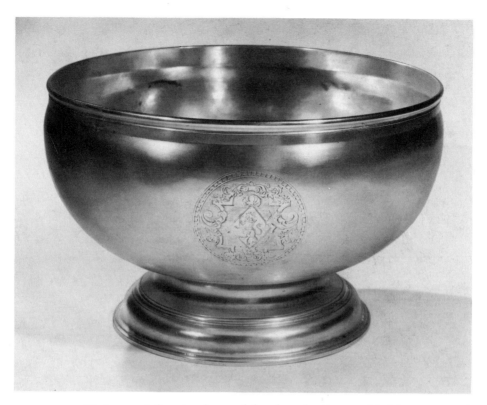

Plate 42 A fine simple punch bowl on circular moulded foot, engraved with a coat-of-arms within a circular medallion. It is 9¼ in. in diameter, weighs 33 oz. 8 dwt., and was made by Thomas Farrer in 1731. Bowls of this type were in fact made from the early years of the century, and continued in fashion until about 1770, early examples usually having a detachable rim which was often scalloped.

Opposite

Plate 41 With small teapots, large kettles were needed to ensure plenty of hot water for replenishment. This tea-kettle and stand, made by Lewis Mettayer in 1708, is of exceptionally large size. It stands 16½ in. high and weighs no less than 128 oz. The design is typical of the Queen Anne and George I periods, with circular pear-shaped body, faceted swan-neck spout with so-called duck's head terminal, domed cover and swing handle. Sometimes the body was octagonal. The tripod scroll stand and lamp have heavy cast supports and a circular grooved well for the base of the kettle.

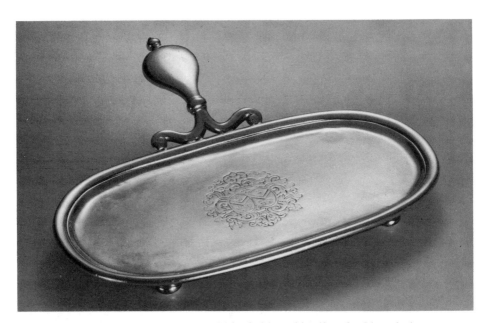

Plate 43 Everything that could be fashioned in silver had its admirers, and small trays for inkpots, snuffers and even spoons for the tea-table were made in large numbers. This oval snuffer tray has a raised moulded rim, and relies for its decoration on the scrollwork back-handle and the engraved coat-of-arms at the centre. It stands on four ball feet and is $8\frac{1}{4}$ in. long. It was made by John Chartier in 1712.

Opposite

Plate 44 One of the most charming styles of dish at this period was the type with fluted sides and scalloped rim, usually termed a strawberry dish – though probably used for all kinds of desserts. This dish made in 1719 by Richard Bayley, is just under 7 in. in diameter, weighs 9 oz. 7 dwt. Note how the armorials inscribed after assay have been engraved off-centre to avoid the hallmarks.

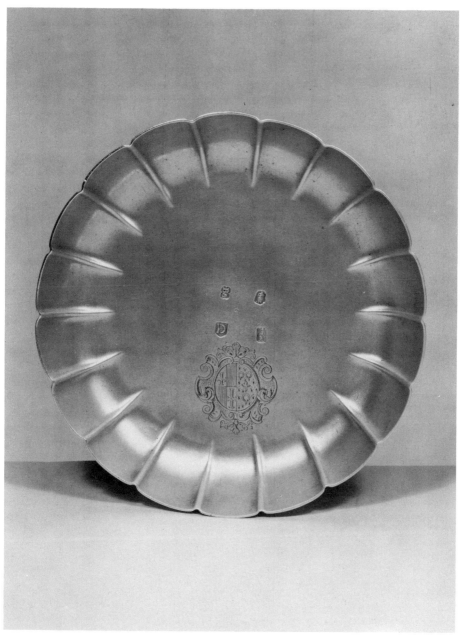

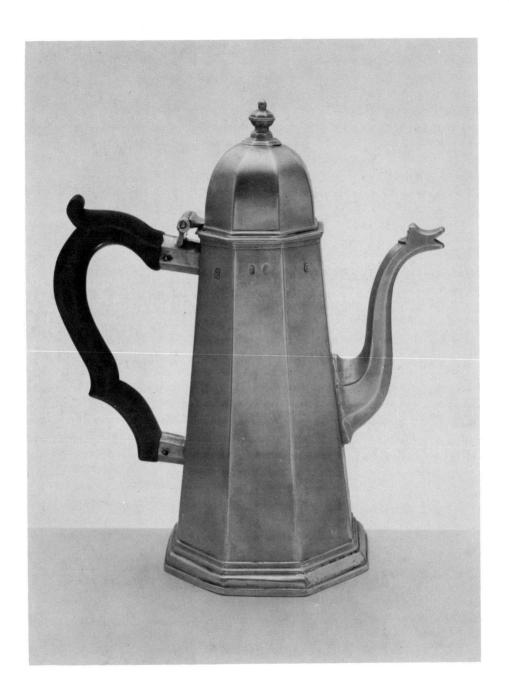

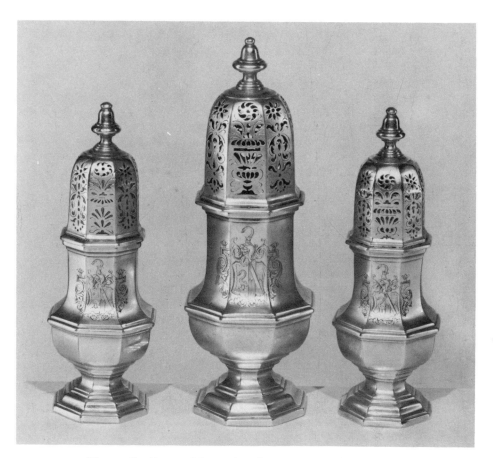

Plate 46 Even without the elegant cartouches surrounding the engraved coats-of-arms, this trio of casters shows the slight trend towards decoration making its appearance in the 1720s. The slide-in octagonal tops of these casters have the pierced vases of flowers and formal scroll and leaf designs accentuated by engraving, though simplicity is still the keynote of the moulded girdles, stepped bases and acorn finials. The tall caster stands 8 in. high, the pair 6½ in. They were made by Edmund Pearce in 1720.

Opposite

Plate 45 Here the unusual seven-sided form is used for the curved spout of an octagonal coffee-pot, on moulded base and with octagonal domed cover. 9½ in. high, and weighing 24 oz. 5 dwt., this pot by Richard Bayley, dated 1718, is typical in size and weight of coffee-pots of the period, and shows haphazard placing of hallmarks.

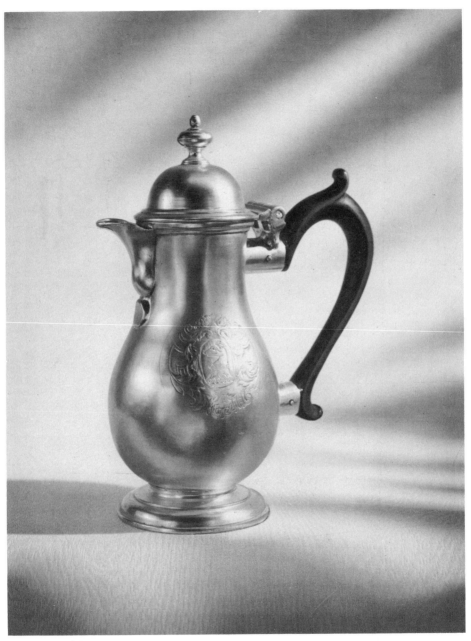

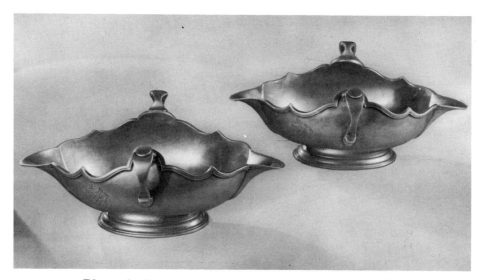

Plate 48 Usually of heavy gauge silver, sauce-boats after about 1712 were given interest by means of shaped, moulded rims and scroll handles on either side. This pair, on oval moulded feet, shows the armorials of the owner placed on one side. They are 8½ in. long, weigh together 27 oz. 15 dwt., and were made in 1721 by Sarah Holaday. Her mark, in a widow's lozenge, was registered in 1719, but like most women silversmiths, she probably supervised the workshop and did not make silver herself.

Opposite

Plate 47 Small, covered jugs, probably used for warm milk or cream, presaged the baluster form later to be taken by coffee- and chocolate-pots and jugs. Though tea was originally taken plain, by the 1720s both sugar and warmed cream became fashionable at the tea-table, and this small covered jug with its raised moulded foot to keep the heat of the contents well away from the tabletop was both functional and attractive. Made by William Fawdery in 1719, it is 5¼ in. high and weighs 7 oz.

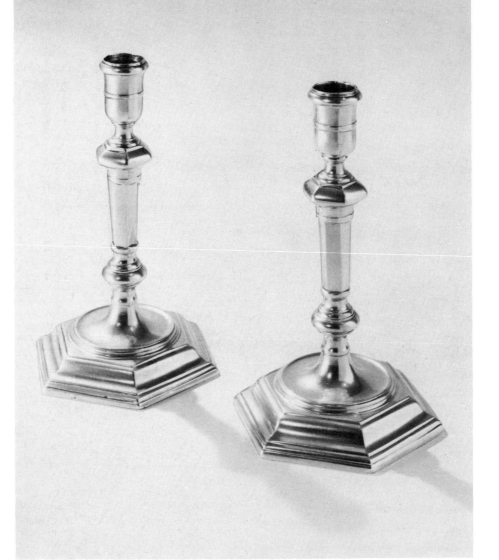

Opposite

Plate 49 Candlesticks and candelabra of the first forty years of the eighteenth century retained the baluster form. Here the hexagonal form is chosen for the moulded bases and tapered stems of a pair of table candlesticks by Thomas Mason, dated 1725. Each is 7 in. high, and they weigh together 25 oz. 5 dwt. The sunk circular wells are engraved, quite typically for the period, with armorials, and the hexagonal form is followed through to the moulded sconces.

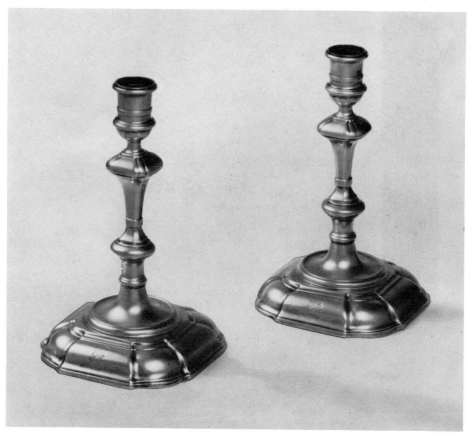

Plate 50 A more decorative variation was the candlestick with rather cushion-like, shaped and moulded base, though here the octagonal still shows its influence, both on the base and the tapered stem. This style was the immediate predecessor of the early rococo candlestick, with the panels on the stem and foot providing a ground for chased strapwork and other ornament. This attractive pair of candlesticks, weighing together 23 oz. 5 dwt., was made by Matthew Cooper in 1727.

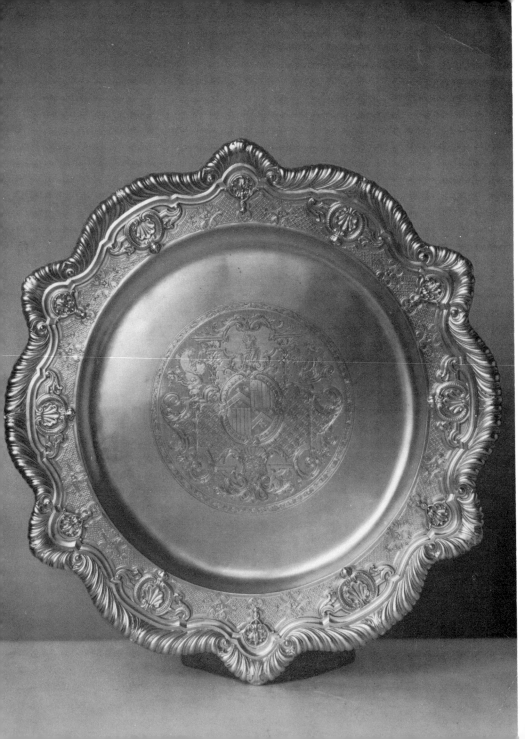

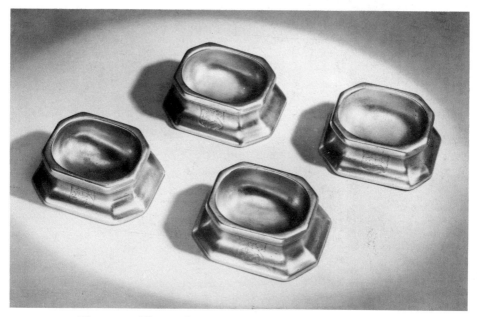

Plate 52 These salts could have been made in any year from 1700 to 1725. Each engraved with a coat-of-arms, they are typical examples of the cast, octagonal trencher salts of the period, usually made in sets of two, four or more. These, dated 1720, are by John White.

Opposite

Plate 51 A superb example of silversmithing and a reflection of the mannered *Régence* style of decoration supremely handled by a young silversmith is this silver charger, made in 1722 by Lamerie. It is engraved in what is known as the Hogarthian style and, indeed, may even be the work of Hogarth, though he soon left the craft he had trained for. The charger is $21\frac{1}{2}$ in. in diameter.

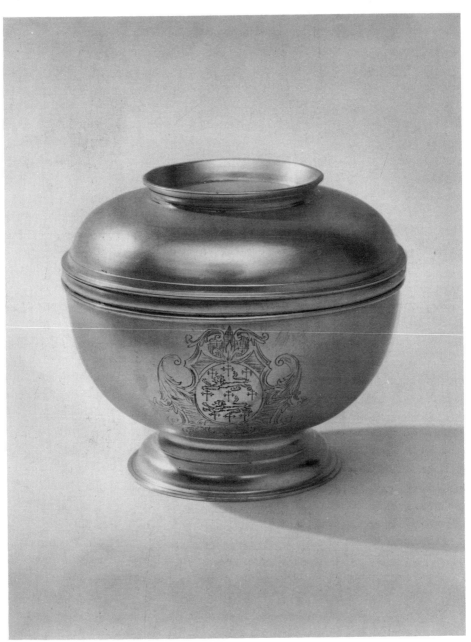

76

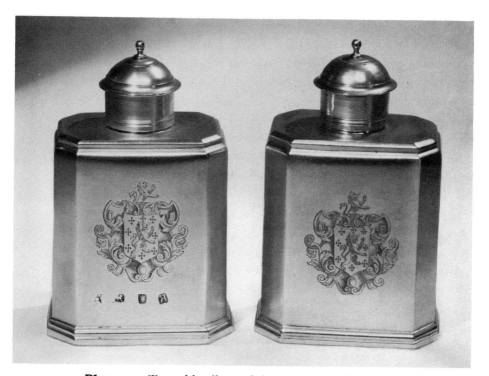

Plate 54 Tea-table silver of the 1720s was frequently quite plain, relying for its attraction on the beauty of its moulded line and the engraver's skill at conceiving a fine cartouche about the owner's coat-of-arms. The tea-table hostess frequently blended her own teas at the table, so that more than one caddy was essential. The tea canister, with sliding base and bottle top, was popular. This pair, made in 1725 by Thomas Tearle, have moulded octagonal bodies, their simplicity relieved only by the engraved coats-of-arms in baroque cartouches on each front.

Opposite

Plate 53 A typical sugar bowl with cover, made by William Fordham in 1730.

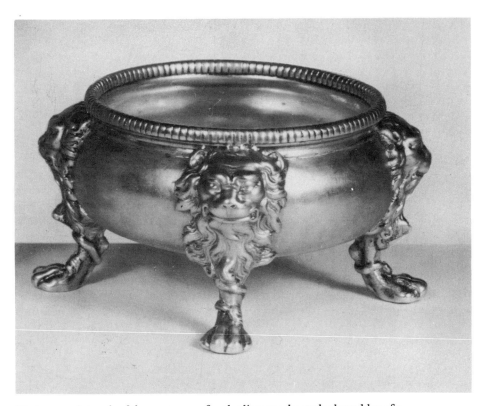

Plate 55 A touch of the grotesque for the lion masks at the knuckles of a circular salt on four paw feet; it is from a set of four made by Paul De Lamerie in 1731. Similar salts, with lion mask and paw decoration, became popular throughout the whole of the rococo period.

Opposite

Plate 56 Chocolate-pot and coffee-pot designs are often indistinguishable, except for the aperture in the cover through which the stirring rod for the chocolate can be inserted. In the early years of the eighteenth century, a tall, tapered cylinder with wood scroll handle and curved spout at right angles to the handle, was the usual form. This chocolate-pot by Gabriel Sleath, made in 1709, has plain flange-like cards encircling the spout and handle sockets. The high-domed cover has a hinged flap below the baluster finial, and a simple thumbpiece with double-corkscrew terminals.

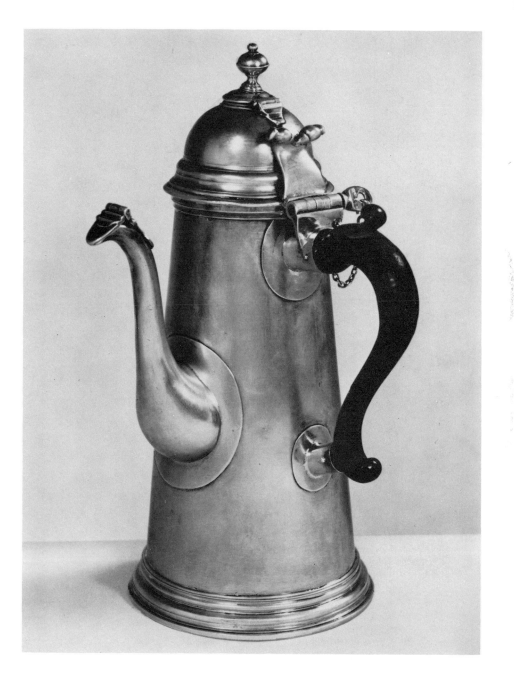

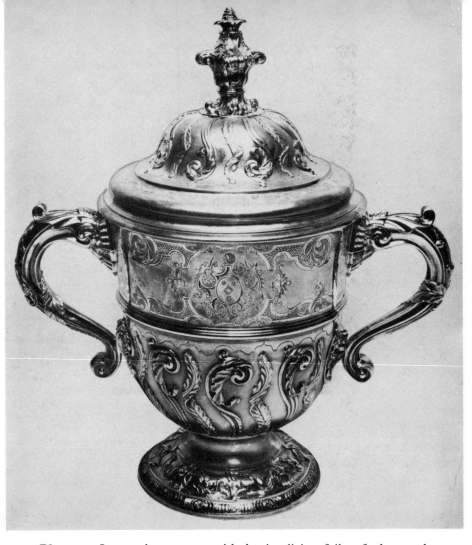

Plate 57 In complete contrast with the simplicity of silver for beer and punch, this cup and cover by Paul De Lamerie, 1733, shows the swirling themes of the rococo overlaid on the simple form of two-handled cup and cover. At the base of the bowl, twisted leaf shapes are applied on a matted ground, with scrolling foliage and scalework from a border between the rim and the central moulded rib, enclosing an elaborate coat-of-arms in a baroque cartouche. More leafage swirls around the scroll handles and up the domed cover to the finial. This confection in silver, only $12\frac{1}{2}$ in. high, weighs 72 oz. 3 dwt.

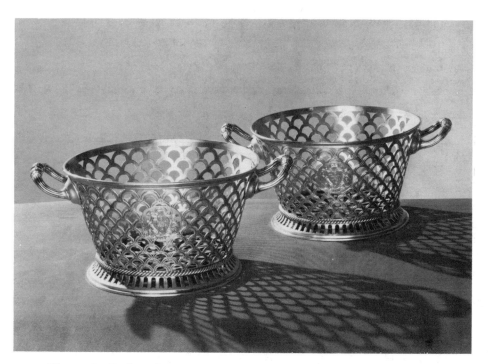

Plate 58 Baskets for cake, bread and fruit were known from Tudor times, and in this pair of 1734 Paul De Lamerie harked back to a much earlier style. By the early years of the eighteenth century, most baskets were oval, and the swing handle design rapidly became popular, though some baskets continued to be made with end handles. Until the mid 1730s, piercing was usually formal and repetitive, many baskets simulating wickerwork. Only 5½ in. high, these two baskets weigh together 81 oz. 10 dwt.

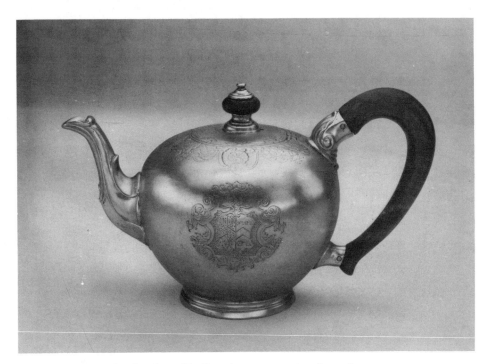

Plate 59 Basically simple, of bullet shape on a rim foot, the teapot gradually acquired some of the trappings of the rococo. Here, shells, scrolls and strapwork overlap shoulders and flat lid, while the curved spout is enriched with petal-like faceting and the upper handle-socket is leaf-capped. The engraved arms, in foliate cartouche, repeat the decorative theme of the rest of this piece. The pot, made by Gabriel Sleath in 1733, weighs 13 oz. 2 dwt.

Opposite

Plate 60 Enrichment of the otherwise simple globular tea-kettle was made easier by its having a stand and lamp. Here the faceted spout and shoulders bear shell and scroll ornament, while the silversmith, Edward Vincent, has been able to express the rococo love of decoration in the pierced apron concealing the lamp. Masks, fruit swags, scrolls and foliage are pierced and chased between the paw-footed tripod supports of the stand, of which even the frame at the top is notched into a wavy-edge design. The kettle together with its stand and lamp were all made by Vincent in 1734.

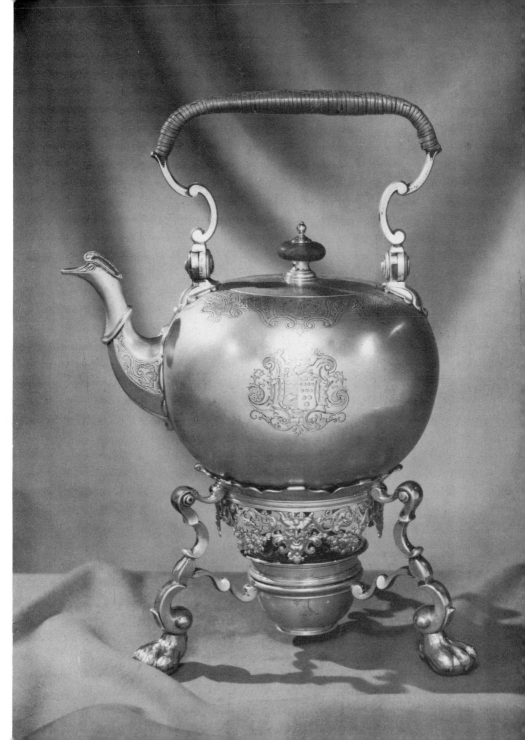

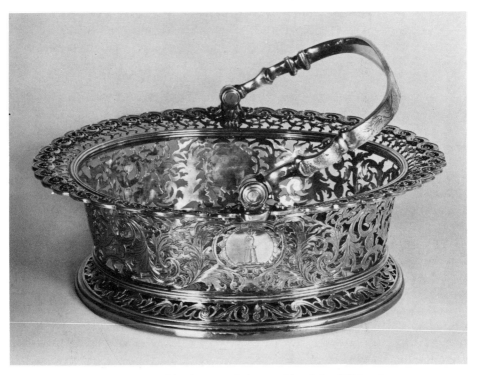

Plate 61 This very fine oval basket, made in 1736 by John White, has the sides pierced in a flowing design, picked out with engraving. The oval foot is also pierced out with scrollwork, while the everted rim is pierced into leaf designs and bordered with an unusual mount, formed of chased and matted guilloche pattern. The base and swing handle are engraved with yet more foliage and strapwork.

Opposite

Plate 62 A small coffee-pot by Charles Kandler which has all the evidence of Continental inspiration for the English rococo movement. Fluting is used for a baluster-bodied pot lavishly enriched with scrolls, shells, foliage, strapwork, trelliswork and matting. The curved spout is leaf-capped and the base is richly chased with scrolls, a feature echoed in the sockets for the wood handle.

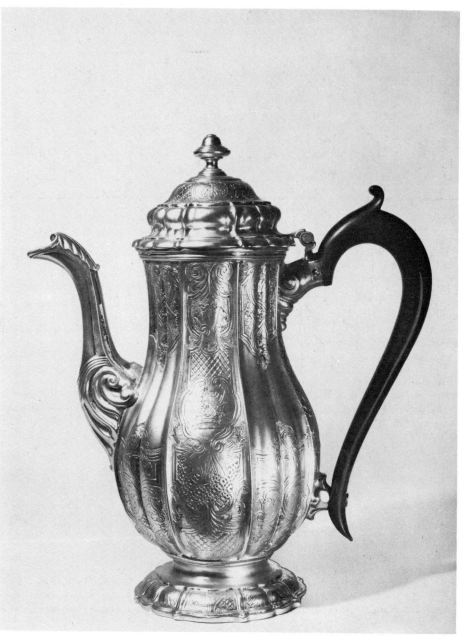

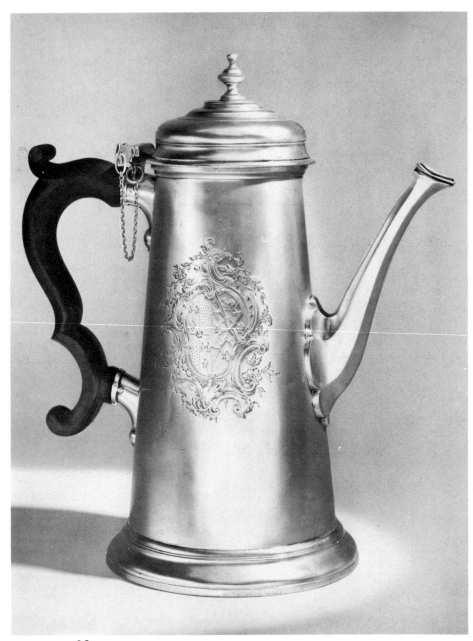

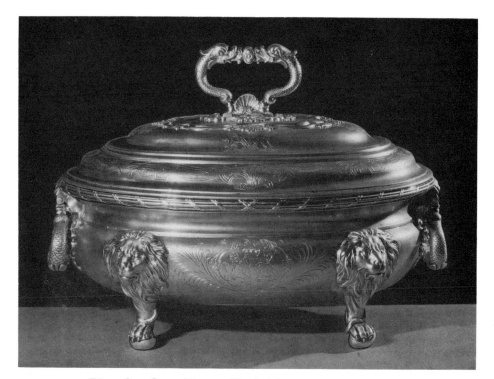

Plate 64 One of the two Hardwicke tureens, made by Paul De Lamerie in 1734 and 1737, and now in The Minneapolis Museum of Art. They are of magnificent proportions, 13¾ in. long, and weighing together 359 oz. 13 dwt. The boldly modelled lion masks and the charming sea-serpent handles are fantasies compensated for by the simplicity of the reed and tie rims, the mobile yet orderly border to the domed cover and the simple swell of the body. The arms are those of Philip Yorke, who was created Baron Hardwicke in 1733.

Opposite

Plate 63 Even in the great ages of decorative domestic silver, there was always a demand for less ornate styles; partly on account of taste, partly, no doubt, because of the expense of decoration. In the early rococo period, the tapered cylinder was still the predominating form for chocolate and coffee-pots, though by the 1730s the high-domed cover was distinctly out of date and most covers were much flatter. The rim foot, too, often spread out further. This fine chocolate-pot by Richard Beale, made in 1734, weighing 32 oz. 5 dwt. and 9½ in. in height, is a good example of the plain style, its only concession to the new ornament being a beautiful cartouche swirling around the coat-of-arms on the side.

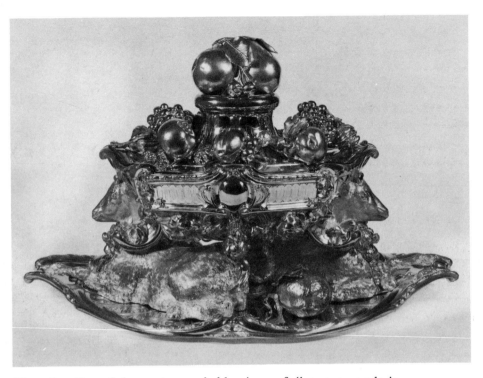

Plate 65 One of the most remarkable pieces of silver ever made in England is this soup tureen and stand made by Paul Crespin in 1740. Here is rococo sculpture in silver at its most exotic. Models of hinds support an oval vase-shaped bowl which is festooned with cast and chased flowers and foliage. The fluted cover is a riot of grapes, pears, plums and apples, held in place by screws, while citrus fruits are set between the hinds on the oval dish; 21¾ in. overall, this piece of magnificence in silver weighs 524 oz.

Opposite

Plate 66 This chocolate-pot by Paul Crespin is very unusual. Of plain bottle form, with bold handle, the stepped, domed cover has a hinged baluster cover through which the stirring rod is inserted. This is a long and heavy whisk, with six wood flanges at the end, and mounted in silver. To insert it, it is necessary to remove the whole cover. Made in 1738, the pot is inscribed as the gift of the Earl of Dysart to Mrs. Tollemache in 1791, and bears a later coat-of-arms. It is another example of the fine silver in the Farrer Collection at the Ashmolean Museum.

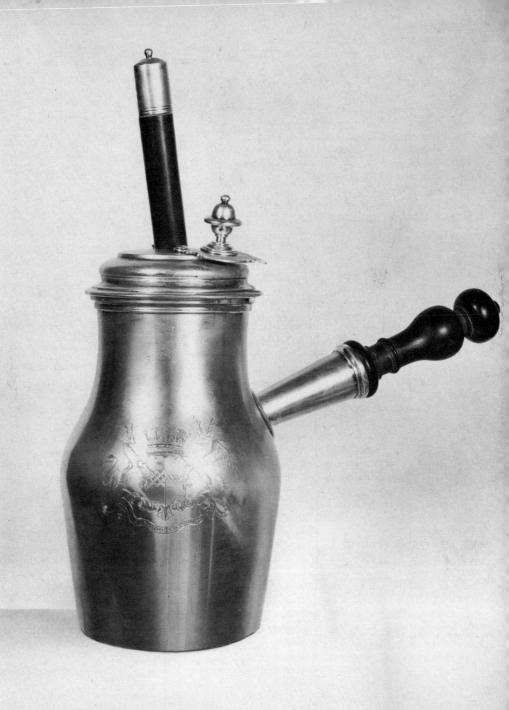

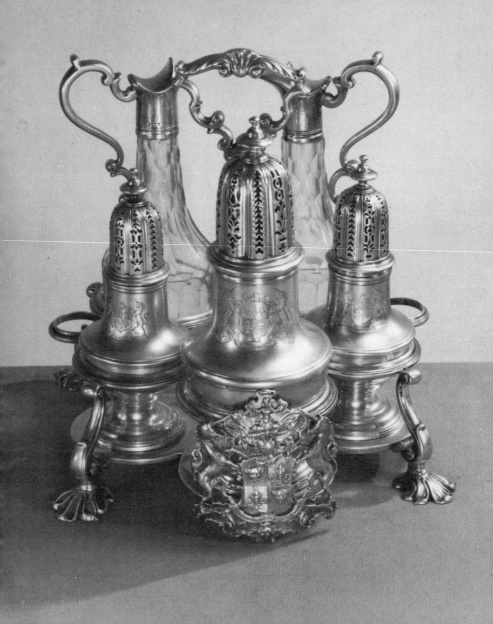

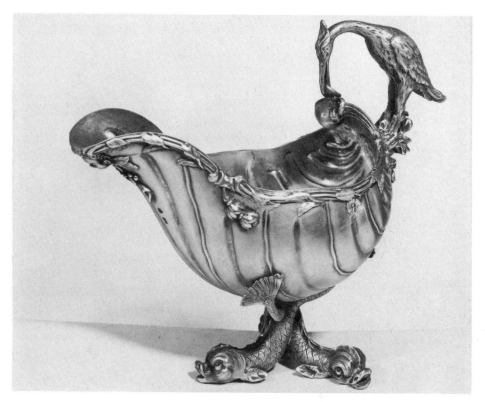

Plate 68 One of a pair of George II sauceboats, engraved with identical crests, the deep fluted shell-shaped bodies chased at the reeded rims with flowers and leafage and beneath the lips with cherub's masks in relief and berried foliage, the handles formed as a crane standing on a foliate branch, each resting on a foot of three entwined dolphins, 9 in., by William Cripps, 1749, 59 oz.

Opposite

Plate 67 Among the pieces commissioned by the Worshipful Company of Goldsmiths to replace plate lost in earlier times was this fine Warwick cruet, one of a pair made for the Company by Richard Bayley in 1740. The vase-shaped casters with their elongated husk and scroll piercing and the elegant, silver-mounted oil and vinegar bottles are typical of the restrained styles that survived even in the high rococo period – a glimpse of which is seen in the decorative scroll and petal feet and the rich shell and foliate encrusted ground for the Company arms which appear in chased relief.

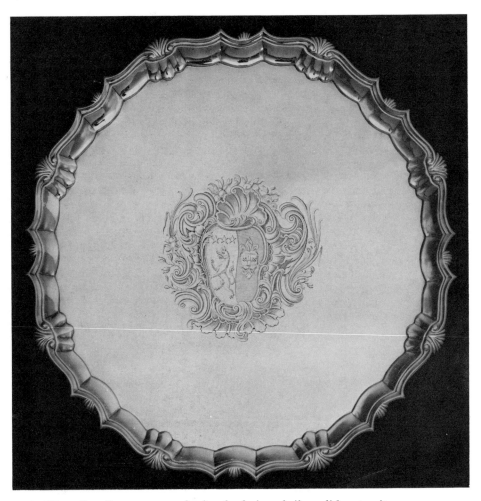

Plate 69 Even apparently simply designed silver did not quite escape the influence of the rococo. This large circular salver, with its shaped moulded rim and orderly arrangement of scrolls and shell motifs, merely hints at the rococo, though the engraved coat-of-arms at once betrays the full influence of the style, with its elaborate asymmetrical cartouche. The salver, 14 in. in diameter, and weighing 51 oz., was made in 1744 by Robert Abercrombie, a silversmith who largely specialised in the skilled work of making trays.

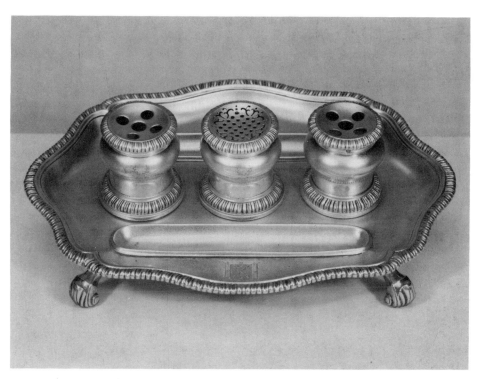

Plate 70 This inkstand on four scroll feet, shows the mid-eighteenth century liking for a shaped stand, but retains the formal gadrooned borders of the baroque period. There is a shallow well on either side of the three vase-shaped pots for ink and pounce. One pot is later, dated 1804, perhaps a replacement for a lost bell or another sand-box; $11\frac{1}{2}$ in. wide, the stand weighs 44 oz. 17 dwt. Made in 1747 by William Cripps.

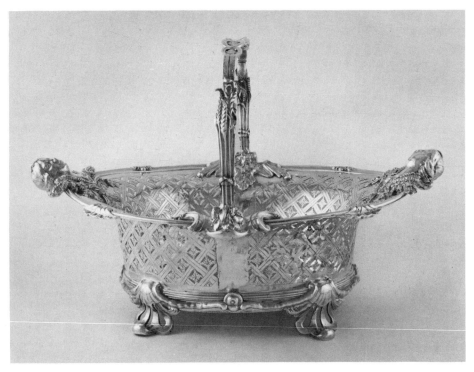

Plate 71 Nicholas Sprimont was a silversmith who in 1749 became the manager of the Chelsea Porcelain factory. His feeling for the rococo was, even in silver, almost that of the potter. This deep oval cake basket, made in 1745, in fact shows a detail very akin to English porcelain patterns. It stands on bold cast and pierced scroll feet with shell knuckles, and finely modelled heads rise from naturalistic wheatsheaf sprays at either end. The wheat theme is repeated along the handle, which rises from finely modelled flowers and foliage, while the sides are a trelliswork of engraved lattices and flowerhead motifs.

Opposite

Plate 72 Candlesticks were an ideal subject for the rococoists, since the ornament could hardly interfere with function. This candlestick from a set of four, is cast and chased in high relief with three dolphins between three different masks set amid scrolls and wave-like motifs which rise to the shell-encrusted chased and matted baluster stem. Swirled fluting, foliage and scrolls decorate the sconce. The detail of the cast chasing can perhaps best be appreciated with the information that the candlestick is only 9½ in. high. Made by John Jacob in 1740 it is now in the Farrer Collection, Ashmolean Museum, Oxford.

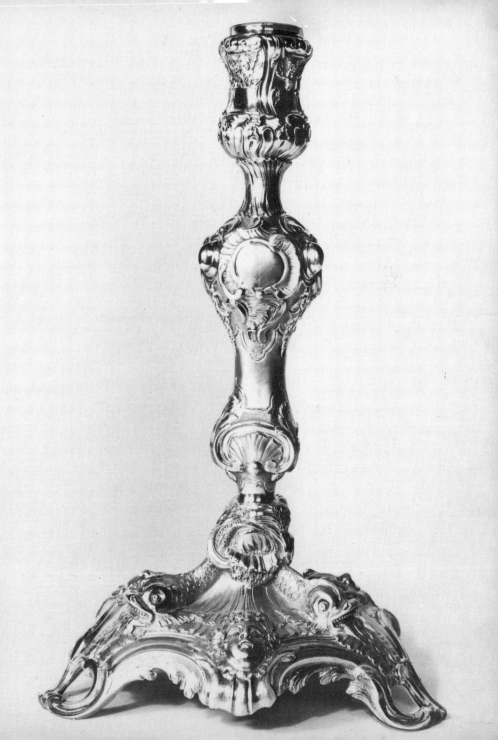

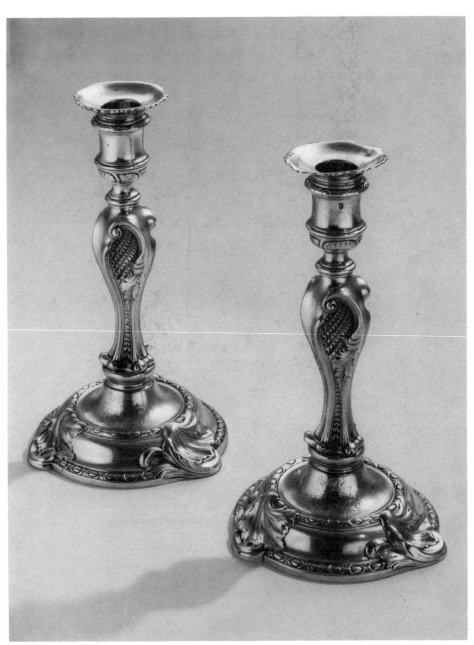

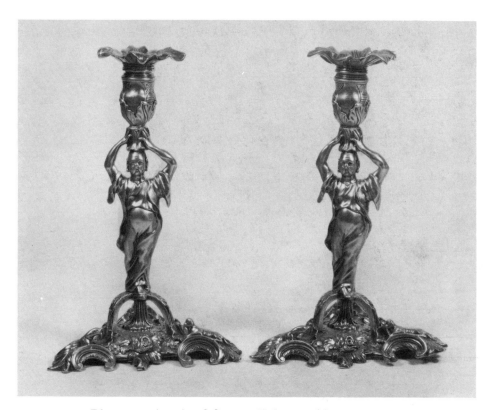

Plate 74 A pair of George II large table-candlesticks, which stand 11 in. high and weigh 172 oz. The stems are formed in the shape of Chinamen holding vase-shaped sockets, chased with basket work and foliage, above their heads. They stand on tripled arches on shaped triangular bases, which are decorated with flowers and foliage. The scroll feet are surmounted by animals and birds in relief. The sockets have petal-shaped detachable nozzles. They were made by John Cafe in 1753.

Opposite

Plate 73 Here William Cripps interprets the rococo by suggestion rather than letting it dominate his design. The circular bases, with a formal border of guilloches, are charmingly applied with swirling foliage. The stems, rising from scrolls, are chased with husks that swell into leaf-bordered scrolls enclosing scalework, asymmetrical yet orderly. Formality also typifies the simple borders for the sconces. Made in 1747, they weigh 46 oz.

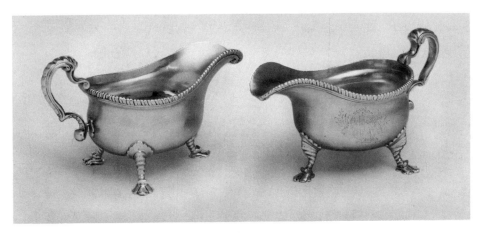

Plate 75 Dining-table silver of the mid-eighteenth century was usually sturdy. These two sauce boats, made by Daniel Piers in 1749, together weigh 27 oz. 4 dwt. The unusual 'quilted' decoration on the feet and double-scroll handles is one that appears to have been introduced from the Continent at a time when many patrons were beginning to tire of the meanderings of the rococo; it was even on occasions used for candlestick stems and for the bodies of tureens. On these sauce boats, the asymmetry of the engraved coats-of-arms in their rococo cartouches contrasts with the formal simplicity of the gadrooned borders.

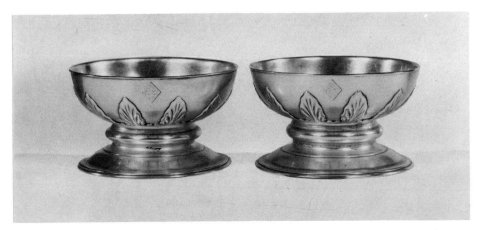

Plate 76 Here Paul De Lameria uses the pedestal style for a pair of circular salts of 1748, each on a spreading moulded foot with knopped section above and applied palm leaves at the base of the circular bowl.

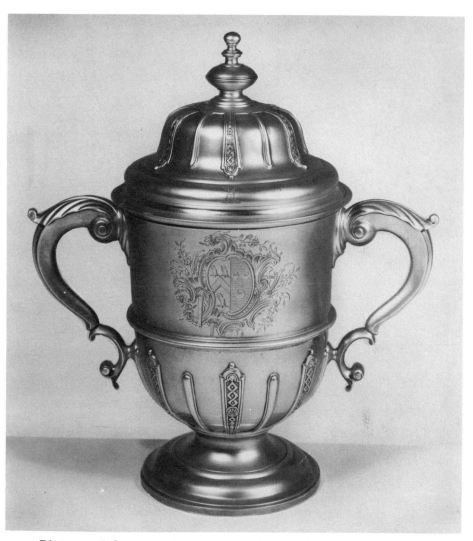

Plate 77 A fine cup and cover of 1753 that could well have been made thirty years earlier. Its formal applied strapwork at the base of the body and on the domed cover, the leaf-capped, double-scroll handles, and the moulded rib about the lower part of the body betoken the still-abiding influence of the early Huguenot period. The engraved coat-of-arms and its flowing rococo cartouche indicate the later date of the engraving, which is, in fact, also confirmed by the hallmark for 1753 and the maker's mark – that of John Swift.

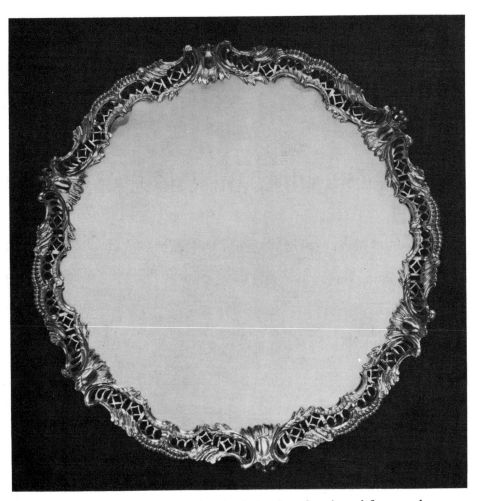

Plate 78 A touch of the chinoiserie inspires the pierced frets on the border of this beautiful salver made by Edward Aldridge and John Stamper in 1758. Around the pierced gallery, the border is shaped with gadroons, shells and scrollwork in finely cast and chased work that contrasts sharply with the absolute plainness of the centre. Weighing 51 oz. 8 dwt., the salver is $13\frac{7}{8}$ in. in diameter.

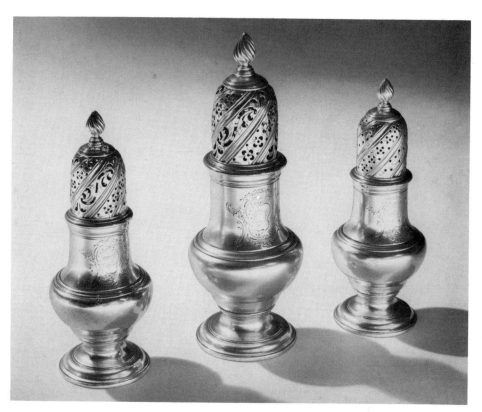

Plate 79 Specialist makers often concentrated on certain groups of silver and supplied the trade with wares such as salvers, salts, casters and even epergnes. One of the noted makers of casters was Samuel Wood of Gutter Lane, and even within the limitations of the vase shape, he managed to achieve variations so that it is often difficult to find a pair or a trio alike. Here three matching casters of 1755 have the domed covers pierced with spiral fluting and foliage, one of the smaller pair being less openly pierced, presumably for use as a pepper caster. The tallest is just under 8 in. high.

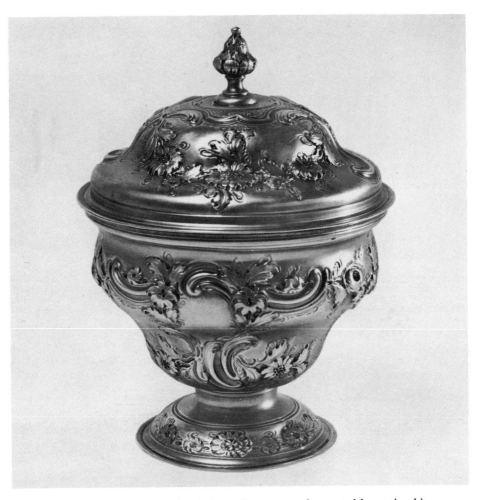

Plate 80 Throughout the eighteenth century, the tea-table retained its position as the centre of conversation in society. Literature of the period is full of tea-drinkings, and no well-appointed drawing room was complete without tea-table silver. Tea caddies, often made en suite with sugar bowls, became box-like or bowl-like, instead of following the bottle-topped canister styles of the early years of the century. A specialist maker of caddies was Samuel Taylor, who made this rococo caddy of circular form, repoussé chased with asymmetrical scrolls and bold festoons of different fruits and flowers, in 1759. 6 in. high, it weighs just 10 oz.

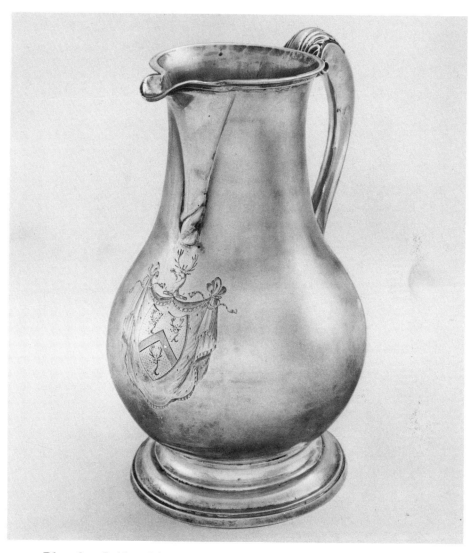

Plate 81 Bold, weighty and simple – the keynotes of many fine baluster-shaped jugs, probably most used for beer throughout the eighteenth century. Indeed, many are inscribed with labels such as 'Small' and 'Strong', or with the initials 'A' and 'B' for ale and beer. This sturdy jug, weighing 52 oz. 17 dwt., has typical moulded circular foot, baluster body with moulded rim and short spout decorated by the leaf-capped scroll handle and shell motif below the lip. Shaw and Priest, 1758.

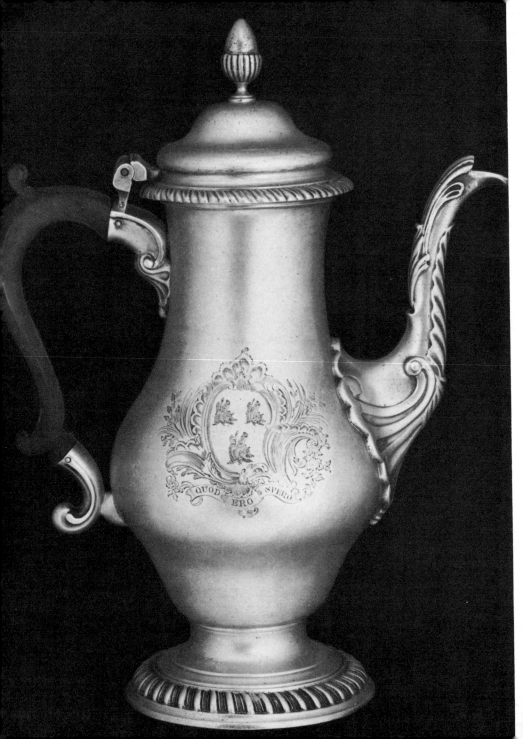

QUOD ERO SPERO

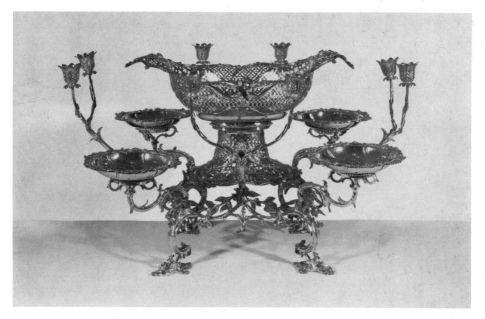

Plate 83 The 1760s were especially notable years for the centrepiece or epergne. A noted maker of epergnes was the immigrant Norwegian, Emick Romer, while Thomas Pitts, who was recorded in Air Street, Piccadilly, from 1767 until 1793, supplied nothing but epergnes to the distinguished firm of Parker and Wakelin. This elaborate example by Pitts, made in 1763, its base a lattice of scrolls and foliage rising to a lacy stem and oval basket, also features four sets of candle branches. 13 in. high, it weighs 206 oz. 3 dwt.

Opposite

Plate 82 The tall, baluster-shaped coffee-pot on a circular foot came into fashion round about 1755. The cover of these new-style pots became rather more domed, while the curved spout was often decorated with scroll, leaf or even fantastic ornament, an eye-like motif often appearing above the beak of the spout. Acorn or flame finials were popular, as on this coffee-pot by Jacob Marsh, which is dated 1768. The pot, 10¾ in. high, weighs 27 oz., and features applied leafage on the spout and scroll decoration at the socket of the wood handle.

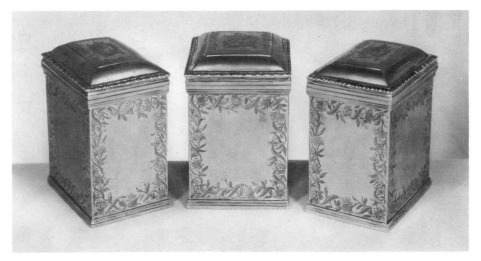

Top

Plate 84 More austere, a trio of caddies and a sugar box by Albert Shurman, made one year later in 1764. Of rectangular form, each side is engraved with borders of flowers and foliage. Narrow gadroons edge the shallow-domed covers, which have similar borders of flowers around the engraved arms of Vansittart impaling Morse on the top of each. Each of the two caddies is 2¾ in. wide, the sugar box is 3¼ in. wide, and the three weigh together 43 oz. 13 dwt.

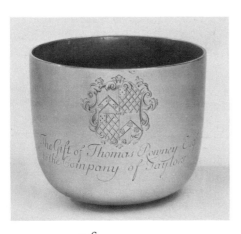

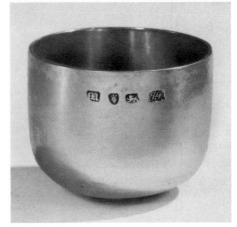

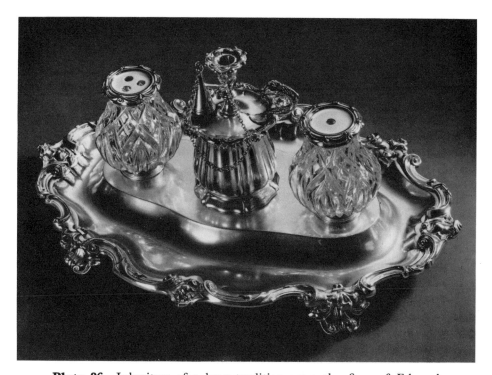

Plate 86 Inheritors of a long tradition were the firm of Edward Barnard & Sons, who could trace their history back to the Nelmes in the early 1700s. This fine large inkstand, on four bold scroll feet, was made in 1856. In an age of steel pens and blotting paper, most of the accoutrements of the traditional inkstand remain, even to a sand caster, now of cut glass mounted with silver. A charming feature is the taperstick with cast chased dolphin handle.

Bottom opposite

Plate 85 Tumbler cups were made in all sizes from the seventeenth century onwards, and were often presented and inscribed, as this one of 1727 by John White, given in 1728 by Thomas Rowney to the Merchant Taylors' Company of Oxford. $3\frac{1}{4}$ inches in diameter, it weighs a sturdy 6 oz. The other cup is by John Payne and was made in 1767.

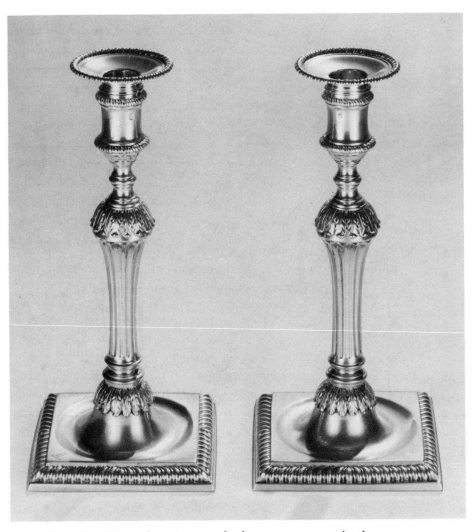

Plate 87 Hints of a return to the baroque are seen in these square-based candlesticks made by John Romer in 1771. Standing 12 in. high, and weighing 46 oz., they have a boldly gadrooned base and socket, and a gadrooned border to the detachable sconce. The leaf-chased and fluted stem rises from a plain well, the tapered fluting giving it an elegantly slender appearance.

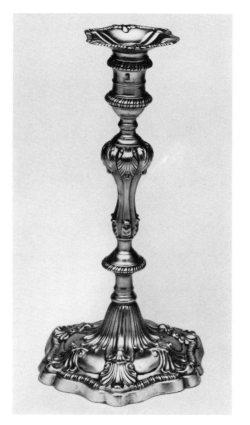
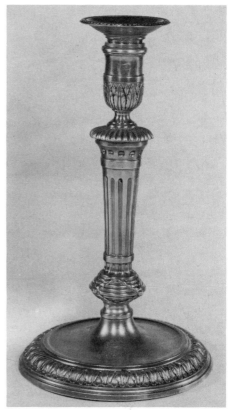

Plate 88 The 1760s were years of somewhat indecisive style in English silver. People were tired of asymmetry. Some designers turned to France for new inspiration, some attempted to modify the rococo, others looked further back to the rich dignity of the baroque. Here Ebenezer Coker harnesses the motifs of the rococo for a candlestick from a set of eight made in 1768; 11 in. high, fluted stems rise from shaped shell-chased bases; the shoulders are chased with formal shell motifs, and the borders gadrooned. The eight sticks together weigh 183 oz. 10 dwt.

Plate 89 French styles at the period were already formal, and in this candlestick from a set of four, made in 1767 and 1771, William Cripps offers his version of the French formality. The circular base is chased with a border of foliage, and is otherwise plain except for the owner's arms. A knop of reed and ribbon design acts as a base for the tapered, fluted stem which is also fluted at the shoulder and from which rise the palm-leaf chased sockets; 9 in. high, the four candlesticks weigh 93 oz. 3 dwt.

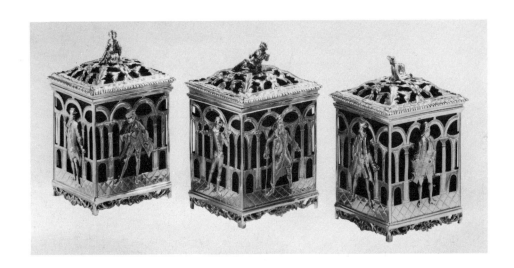

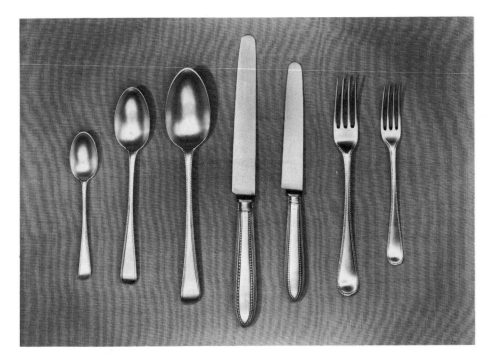

◀ **Plate 90** One of the delights of English silver is that so often there is a gentle sense of humour, even of satire, in the decoration. In the late seventeenth century, chinoiseries had a simple smiling aspect. Half a century later, in 1723, the engraver of the Treby punch bowl, probably Hogarth, peopled the sides for the maker, Paul De Lamerie. In the 1750's, chinoiseries returned in a new guise – flowery and rococo. After the rococo, the sense of humour remained – as in this set of pierced caddies and sugar box, with blue glass liners gleaming through scenes pierced on the rectangular sides, and with other figures perched as finials on the foliate covers. By William Vincent, 1771.

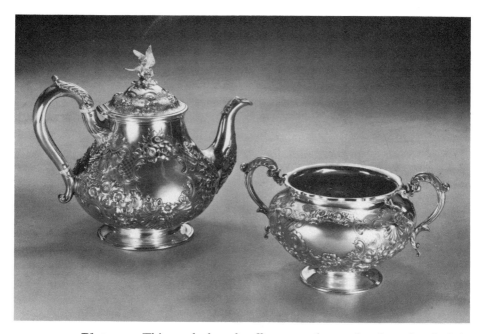

Plate 92 This much chased coffee-pot and sugar bowl are dated 1858. They provide a good example of the scroll and flower style of the period, which was often applied to earlier plain silver by would-be 'improvers'.

◀ **Plate 91** Beading was less common on cutlery and flatware than feather-edge with a slanted cut flute, or the plain Old English pattern with flat stem and rounded end that dominated tableware designs from the mid-eighteenth century onwards, and which is still made. Matched sets of cutlery and flatware are very rare, and most sets are often deficient in the number of forks and almost always of knives. This set with beaded borders dates between 1775 and 1781.

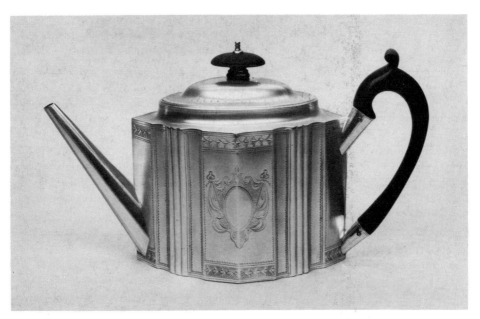

Plate 93 Silver by the Bateman Family has won for itself a special place among collectors, very largely because of the glamour associated with a woman's running a silver business. Hester Bateman was no doubt a very hard-headed businesswoman, a trait apparent also in her daughter-in-law, Ann, who registered her mark with Peter Bateman in 1791. Just before then, in 1790, the rarest of all the Bateman marks was registered – that of Peter and his brother Jonathan. This teapot, typical of its date, with its panels edged with bright-cut engraving, its draped and festooned engraved cartouche, oval, domed cover and straight spout, was made by Peter and Jonathan Bateman in 1790.

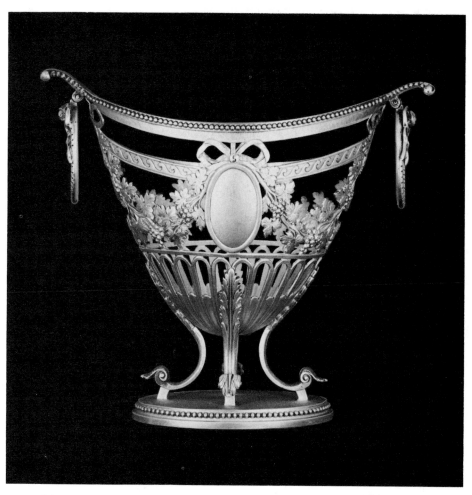

Plate 94 Not all Adam period silver was plain, though much owed something to classical inspiration, despite the fact that few pieces of classical metalwork were known. Vase and boat shapes dominated form, sometimes charmingly pierced out to take blue glass liners – as with this delicate sugar basket made by Robert Hennell in 1782. Beading, vine festoons, a beribboned oval plaque and ring handles are marks of neo-classicism, while the form echoes a classical footed stand. The basket is 6¼ in. high. Robert Hennell, who completed his apprenticeship in 1763, was one of a long- and still-working family of silversmiths. In 1773 he set up on his own account as a saltmaker.

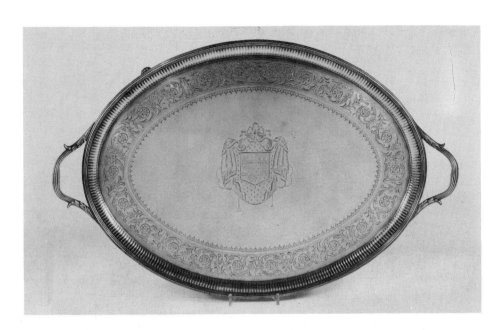

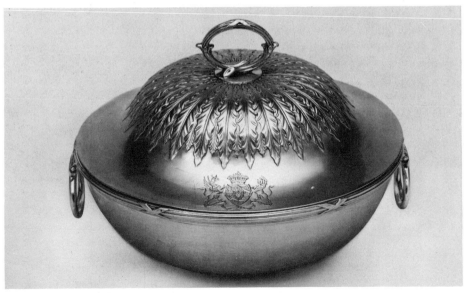

Plate 95 Two London silversmiths who seem to have specialised in the very particular craft of making trays were John Crouch and Thomas Hannam. Many trays were very large – up to 40 in. wide – and comparably heavy, perhaps 320 or even 340 oz. Simple reeded or beaded borders with matching handles sheathed in leafage were almost standard, though a fluted inner border was also a favourite style. The tray shown is 23 in. wide, weighs 118 oz. 16 dwt., and was made by Hannam and Crouch in 1793.

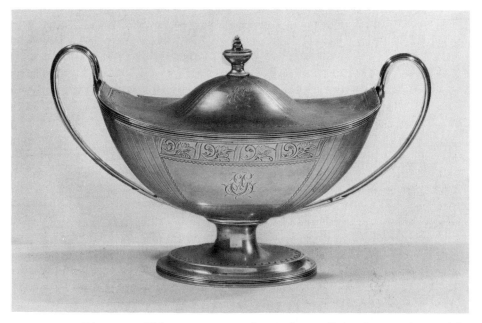

Plate 97 This sauce tureen of 1795 shows all the characteristics of the 'oval' period. On an oval reeded foot, and with reeded loop handles accentuating the oval form of the body, the tureen is delicately engraved with bright-cut foliage below the reeded rims, and with bright-cut panels on either end. The tureen is one of a pair which weigh 36 oz. 14 dwt.; they were made by John Robins.

Plate 96 This circular vegetable dish made by Paul Storr in 1794, shows the silversmith's mastery of chasing and his innate liking for simplicity of line. The plain bodies have drop handles, and have reed-and-tie rims. The covers, chased with radiating palm leafage, have reeded handles, and are engraved with armorials. The dish is one of a set of four, together weighing 127 oz. 16 dwt.

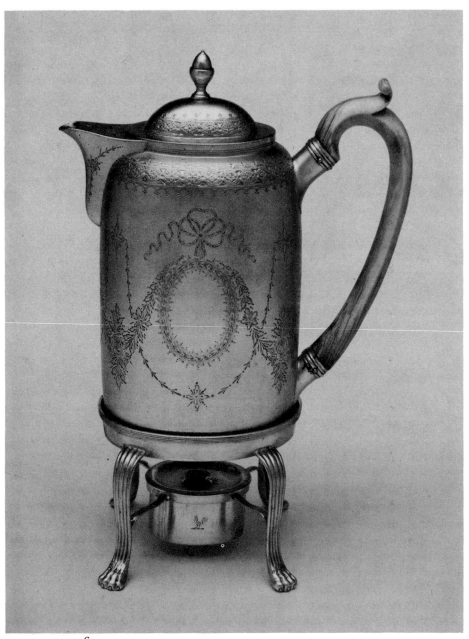

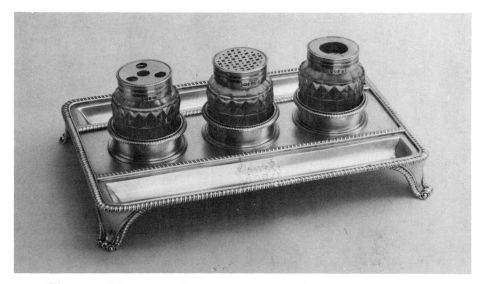

Plate 99 The more traditional type of standish or inkstand formed as a rectangular tray with depressions for pens and containers for ink and sand never lost its popularity. Here the stand has a gadrooned border and panel feet, while the now almost standard glass with silver mounts is used for the bottles. It bears the arms of Francis Godolphin Osborne, 5th Duke of Leeds; made in 1798 by William Simmonds, it weighs 37 oz. 1 dwt.

Opposite

Plate 98 The years at the turn of the century were very much years of invention, innovation, and gadgets for the table. Methods of making coffee and keeping it hot occupied the time of various inventors, including one, called Biggin, who invented a percolater. A number were made in silver, and were accompanied by a stand and lamp. This early example, made by John Emes in 1797 shows the typical short-spouted cylindrical pot, here charmingly engraved with bright-cut festoons. The lamp and stand, with reeded paw feet, are, however, later, and were made in 1821, by another maker, possibly William Sumner.

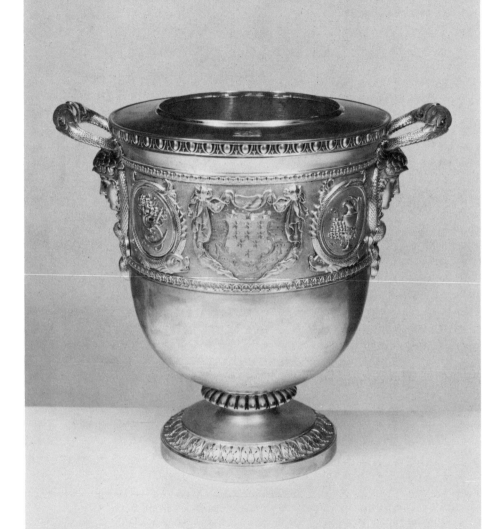

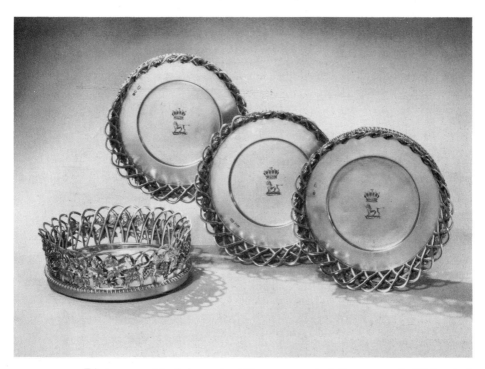

Plate 101 Much important Regency period silver was gilt. This set of four decanter stands by William Burwash, made in 1817, shows the restrained magnificence of the best of Regency plate. The hooped wire sides are overlaid with grapes and wine-leaf motifs, realistically chased and rising from a plain gadrooned rim. The centres are engraved with crests below coronets. Each is 6 in. in diameter, with a wood base.

Opposite

Plate 100 Here Daniel Smith and Robert Sharp apply finely modelled heads of Perseus within the intertwined chased serpent handles of a wine cooler, one of a pair made by them for the leading jewellers, Rundell, Bridge & Rundell in 1804. The band around the top of the vase-shaped bodies encloses medallions within dolphin cartouches of the arts and sciences, and coats-of-arms in draped cartouches. $10\frac{1}{4}$ in. high, the two coolers weigh 248 oz. 8 dwt.

Plate 102 Most of the Rundell, Bridge & Rundell production of the 1820s was based on the designs carried out by Storr and others during the last years of George III. This large soup tureen with half-fluted body, shaped gadrooned and shell border, and reeded and leaf-decorated handles, weighs 107 oz. 15 dwt. It was made by Philip Rundell in 1820.

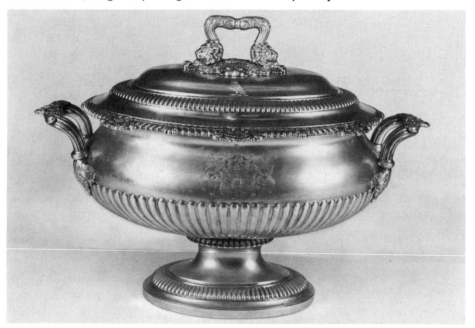

Opposite

Plate 103 This oval silver-gilt cake basket was made in 1820 by J. & E. Terry. On four shell and scroll feet, with broad, everted rim, pierced and chased with horses and hounds amid swags of fruit and flowers, it shows the early nineteenth-century interpretation of the rococo – rather more formal and flowery than that of the middle years of the previous century. There are, however, still touches of humour in the dolphin terminals to the flower-chased swing handle.

Plate 104 Tea-table silver, if less impressive than that for the dining room, was none the less elaborated with ornament in high relief during the 1820s, and was on occasions also gilded – as this five-piece set made in 1822 and 1823 by William Eaton. It is in the popular melon shape with fluted and panelled bodies chased with flowers and foliage, and with rose finials to the hot-water jug, teapot and hot milk jug. Note the unusually large size of both sugar bowl and cream jug. The gross weight of the set is 112 oz. 3 dwt.

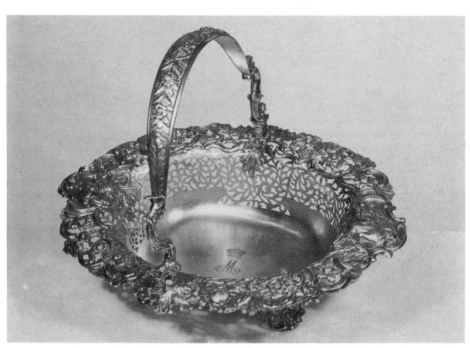

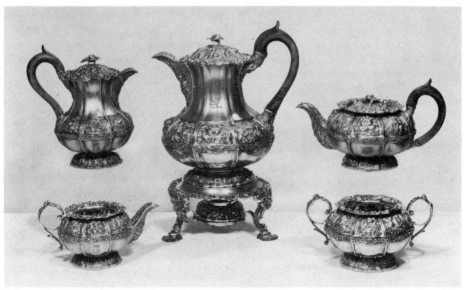

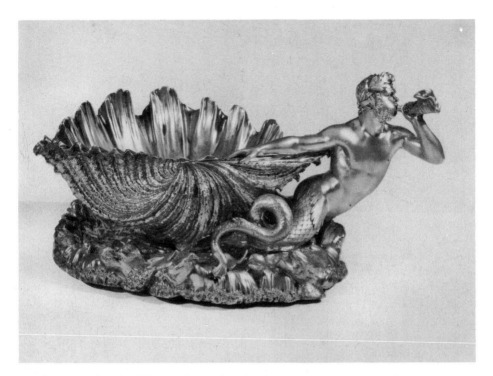

Plate 105 When Paul Storr left Rundell, Bridge & Rundell, apparently in 1819, he opened his own workshops in Clerkenwell, and remained in business until five years before his death in 1844. Among his last works must have been this well-shaped dessert dish from a set of four made in 1838, formerly in the Tollemache Collection. Cast and chased models of tritons blowing conches appear to pull the shell dish along over a rocky base – a single dish weighs over 102 oz. It shows Storr's superb mastery of modelling and of fluidity of form.

Opposite

Plate 106 The impact of the young Robert Adam on architecture and interior design was far-reaching. This neo-classical candlestick, from a pair now in Temple Newsam, Leeds, was made by John Carter in 1767 to a design actually in the Adam drawings in the Soane Collection. Detailed acanthus-leaf borders and a circle of guilloche ornament decorate the base; then acanthus chasing rises to slender flutes, which in turn support a baluster stem of foliage chasing and spiral fluting. Palm leafage above, favoured by the neo-classicists, spreads out to the shoulder; the sockets are rich with palm and acanthus leaves.

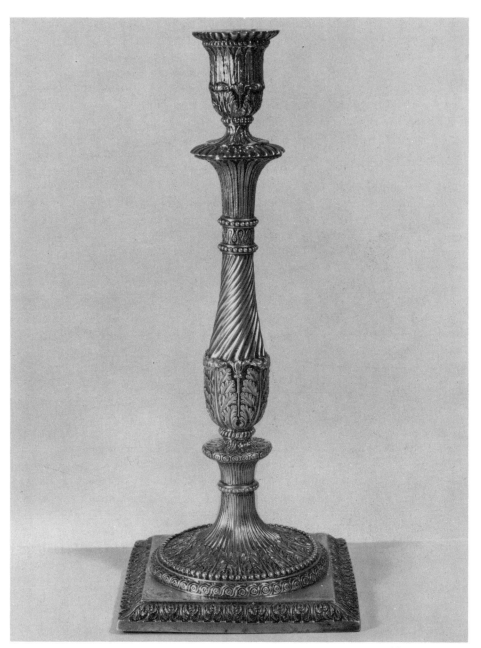

Plate 108 Efforts to improve design standards were legion during the Victorian period, and while few silversmiths could resist the lure of adding decoration, some silver was relatively simple. Even the Gothic revival of the middle part of the century did not entirely overwhelm domestic silver, though ceremonial silver was certainly much more elaborate. This hot-water jug with strapwork decoration above the ovals was part of a tea service of 1853. The half-fluted coffee pot dates from 1861.

Opposite

Plate 107 The rococo influence survived into the last quarter of the nineteenth century, though often in a more restrained and formal manner than before. This fine cruet stand, with scroll-pierced sides, cast scroll feet and shell central handle holds six blue glass bottles for condiments and sauces. It was made by Robert Harper in 1874.

Plate 109 Simple even to a point of plainness, a gravy pot and stand by Charles Aldridge and Henry Green. Often known as argyles, these gravy pots were most necessary vessels in days when kitchens were often far from the dining saloon. An inner section held hot water or a heated billet, keeping the gravy warm. Handles were often insulated with wicker. Strainer holes for the spout were, curiously, often very small indeed. This plain beaded pot was made in 1777, its stand three years later.

Index